LEGENDARY L(

— OF —

ARLINGTON

TEXAS

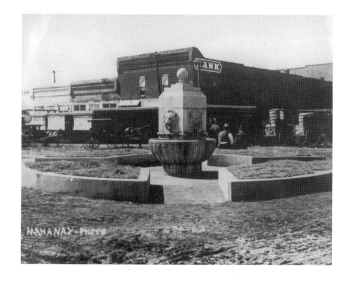

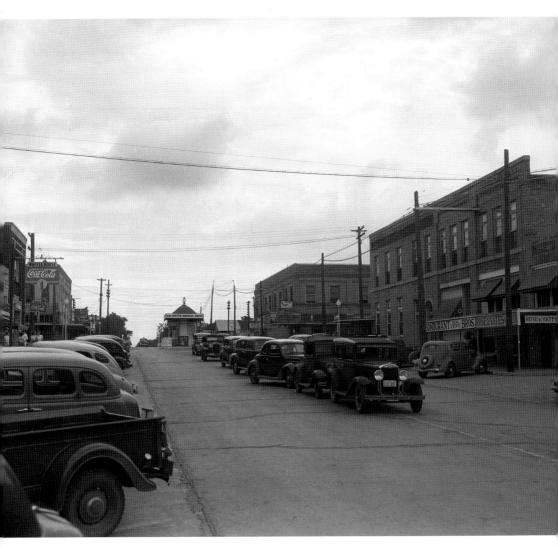

Downtown Arlington
World War II and the end of the Great Depression spurred growth in the 1940s. Arlington rejoiced in new roads and so much business that cars parallel parked down the center of the street. The mineral well, fondly regarded as the heart of the town, is visible at the top of the street. (Courtesy Special Collections, the University of Texas at Arlington Library.)

Page 1: Mineral Well
The mineral well at the intersection of Main and Center Streets played a significant role in Arlington's early history. Citizens gathered at the well for political rallies, parades, and cotton sales. Friends would sit on the rim and exchange the news of the day. (Courtesy Special Collections, the University of Texas at Arlington Library.)

LEGENDARY LOCALS

OF

ARLINGTON
TEXAS

LEA WORCESTER AND EVELYN BARKER

Dedication
For our children: Will, Scott, Jeanine, Laurel, Sonia, Valorie, and Kathy.

On the Cover: From left to right:
(TOP ROW) Nolan Ryan, baseball player (Courtesy of Special Collections, the University of Texas at Arlington Library, see page 120); Kalpana Chawla, astronaut (Courtesy of National Aeronautics and Space Administration, see page 107); Billy Joe Thomas, musician (Courtesy of Special Collections, the University of Texas at Arlington Library, see page 113); Norman L. Robinson, pastor (Courtesy of Special Collections, the University of Texas at Arlington Library, see page 30); William C. Weeks, mayor (Courtesy of Special Collections, the University of Texas at Arlington Library, see page 13).
(MIDDLE ROW) Allan Saxe, political science professor (Courtesy of Special Collections, the University of Texas at Arlington Library, see page 72); Dora Nichols, educator (Courtesy of Special Collections, the University of Texas at Arlington Library, see page 58); Arista Joyner, historian (Courtesy of Special Collections, the University of Texas at Arlington Library, see page 69); Claude "Chena" Gilstrap, coach (Courtesy of Special Collections, the University of Texas at Arlington Library, see page 117); Col. Neel E. Kearby, World War II pilot (Courtesy of National Museum of the United States Air Force, see page 94).
(BOTTOM ROW) Carrie Rogers, City Marshal (Courtesy of Deborah Gardner, see page 21); Tom Vandergriff, mayor (Courtesy of Special Collections, the University of Texas at Arlington Library, see page 24); Edward E. Rankin, merchant (Courtesy of Special Collections, the University of Texas at Arlington Library, see page 61); William L. Barrett, mayor (Courtesy of Special Collections, the University of Texas at Arlington Library, see page 22); Sylvia "Tillie" Burgin, humanitarian (Courtesy of Special Collections, the University of Texas at Arlington Library, see page 33).

CONTENTS

ACKNOWLEDGMENTS

We would like to express our appreciation to the many people who have been instrumental in the successful completion of this book. We are indebted to our colleagues at the University of Texas at Arlington Library—Ann Hodges and Mary Jo Lyons—for their faith in our efforts and generous support. Special recognition is due to library staff Cathy Spitzenberger, Brenda McClurkin, and Sarah-Gail Permantier for their valuable assistance and expertise. We owe a debt of gratitude to the following people and institutions who shared photographs, memorabilia, and memories of an era long gone and who helped us find new sources to explore: the Arlington Police Department, Tim Childress, Robert Crosby, Harold Elliott, Facebook, Deborah Gardner, Linda Seitz, Stuart Taylor, and Jannette Workman. We are thankful for Alan Cochrum's invaluable assistance in reviewing our first draft of the book.

Since the book's success depended in some part upon the prior research of others, acknowledgment goes to Arlington historians Arista Joyner, René Harris, Vickie Bryant, and O.K. Carter for their books and articles about Arlington's history, and J.W. Dunlop for his commitment to the collection of vintage Arlington photographs. Many of the photographs are from the University of Texas at Arlington Library Special Collections, especially the *Arlington Citizen-Journal* Negative Collection, the *Fort Worth Star-Telegram* Collection, and the J.W. Dunlop Photograph Collection. Unless otherwise noted, all images appear courtesy of Special Collections, the University of Texas at Arlington Library.

Above all, we want to thank our families who supported and encouraged us in spite of all the time we spent away from them interviewing and writing. Last and not least, we recognize that there are not enough pages in this book to include the many individuals and their stories that make Arlington a unique and exceptional place to live.

INTRODUCTION

In February 1886, Alice Ford had a problem. What was she going to name her newborn son? The child had been born on a Texas and Pacific train while traveling from Fort Worth to Dallas. When the train finally arrived, the police (without authority, it was noted) promptly named the boy Dallas in that city's honor. But how would the city of Fort Worth feel about that? The whole thing threatened to become yet another squabble between the two cities when the *Fort Worth Daily Gazette* proposed a solution. "Why not compromise the matter and call [the boy] Arlington?"

Arlington's location is both a blessing and (sometimes) a curse. The town formed because the Texas and Pacific Railway Company wanted a stopping point halfway between Dallas and Fort Worth. The company bypassed the established Johnson Station community with its stagecoach stop and ran the lines three miles to the north of that settlement. Immediately, a rough but thriving town erupted around the depot. The first store was James Ditto's general merchandise store and post office on Center Street, but others soon sprang up and prospered around it.

From its earliest days, Arlington touted its location. "Numerous trains run daily over the Texas and Pacific between Dallas and Fort Worth, rendering it an easy matter for residents of Arlington to reach either city in the morning and return in the afternoon," wrote a *Dallas Morning News* special correspondent in 1893. Nine years later, the city had refined its pitch. "Come to Arlington, ye denisons [sic] of Dallas and Fort Worth," urged the *Arlington Journal*, "and live in happiness away from the bustle and care of city life."

People from across the region heard the call, came, and liked what they saw. One major draw was the college. What is today known as the University of Texas at Arlington started out as a private school called Arlington College in 1895. In 1902, the school was taken over by Col. James M. Carlisle and called Carlisle Military Academy: "A High-Grade Preparatory School for Manly Boys." Grubbs Vocational College took over the facilities in 1917 and emphasized agriculture and domestic arts. The school changed yet again to become North Texas Agricultural College (NTAC) in 1923.

Coinciding with the start of a new era in Arlington, NTAC became Arlington State College (ASC) in 1949. ASC was a two-year school, but college and city officials wanted full, four-year status. They finally

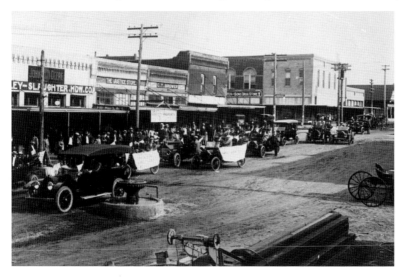

Early Arlington
An unknown photographer captured a parade of automobiles with banners driving past the mineral well on unpaved South Center Street, in Arlington, Texas. Today, the businesses and buildings in the background are long gone.

achieved their dream in 1959, giving the Dallas–Fort Worth area its first public four-year college. In 1967, ASC became the University of Texas at Arlington.

While Arlington had grown and developed in the first half of the 20th century, the second half saw hyper-accelerated change. One man, more than any other, effected that change: Tom Vandergriff.

Vandergriff had moved to Arlington with his family in 1937 from Carrollton, Texas. At first, the young Vandergriff was not impressed. His father, Hooker Vandergriff, had been offered a Chevrolet dealership in either Arlington or Longview, Texas. "I remember thinking as a child sitting in the back seat of my parents' car, Longview was just more impressive than Arlington," said Vandergriff in a 2001 *Dallas Morning News* interview. "Longview had oil wells down the street." But Arlington's location played the deciding factor. "I can hear my father now, just as clearly as if it was yesterday, say that one day Dallas and Fort Worth were going to grow together and it will happen right here [in Arlington]," said Vandergriff.

Vandergriff kept his father's wisdom in mind as he set about serving 13 terms as mayor, from 1951 to 1977, and working to achieve regional harmony. Tom Vandergriff brought a General Motors plant to Arlington and provided jobs for the area. He fought for Arlington State College to become a full degree-granting institution. He supported the creation of Six Flags Over Texas, which drew visitors from around the country. He diligently worked for 13 years to bring Major League Baseball to the Metroplex. He campaigned on behalf of building the Tarrant County Convention Center, which anchors the eastern end of downtown Fort Worth. And he persuaded many local governments to form the North Central Texas Council of Governments.

Vandergriff—and, by extension, Arlington—was never afraid to go up against Dallas and Fort Worth. Although Arlington's central location is an asset, it also means that the city constantly struggles to maintain a separate identity from its larger neighbors. "It's automatic for people outside the area to talk about coming to Dallas," said former mayor Richard Greene in a 2011 *Milwaukee Journal Sentinel* interview. "We know it, we understand it, at the same time we'd like very much for Arlington to get the recognition we deserve."

"We are not naive here in the Mid-Cities area," Vandergriff told the *Dallas Morning News* in 1969. "We realize that our chief asset is that we are a part of the dash between Dallas–Fort Worth. We do think we furnish a lot of the dash and believe we will furnish more and more in the future."

Now, as Arlington moves through the 21st century, location remains its primary asset, but recognition is due to its residents, too. "Arlington is a city with a can-do spirit and a have-done track record," former Mayor Elzie Odom often said. In this book, *Legendary Locals of Arlington*, the authors wish to present a small sample of those can-do people who have created today's Arlington. Some people are still working today, while others left long ago, but all contributed in some way to making this dashing city a vibrant and exciting place to live.

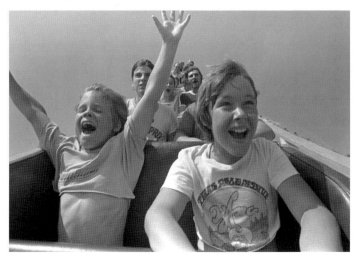

Destination Arlington Steve and Todd Ellington of Arlington enjoy the sensation of a sudden drop on the Judge Roy Scream roller coaster at Six Flags Over Texas theme park in 1980. Developed in 1961, the theme park became the heart of Arlington's entertainment district, which grew to include the Arlington Stadium, Hurricane Harbor, and the recently built Cowboys Stadium.

CHAPTER ONE

The Founding Families

People throughout the ages have found a variety of reasons to make the diverse natural habitat near the Trinity River in north central Texas their home. More than 10,000 years ago, the Clovis people walked the river bottoms and hunted in the rich prairies and post-oak forests. Centuries later, the Caddo Indians farmed the land along Johnson Creek. In 1841, the location with its forest and prairie resources for farming and hunting and its river for transportation attracted the first European settlers who built Bird's Fort on the far north side of Arlington. While Indian raids and hardships led to the fort's failure, the resulting treaty opened the door to settlement. Col. Middleton Tate Johnson was assigned to Kaufman Station, later called Marrow Bone Springs, to enforce the treaty and found a trading post. He established a gristmill, sorghum mill, blacksmith shop, and store in an area soon known as Johnson Station. The Star Mail Route and Trunk Stage line stopped at the store and connected the community with the surrounding areas. Families settled around the station, taking advantage of the river to build mills and the rich land to plant cotton, hay, oats, peanuts, sorghum, and potatoes. A small community to the north called Watson Community developed with a school and chapel.

Soon the resilience of both settlements was tested. The Texas and Pacific Railway built their line to the north of Johnson Station and Watson Community and purchased land for a town site. Railroad access made the new town better suited for growth. James Ditto Sr. was the first to relocate his store and post office to the business area of what would be called Arlington, after Robert E. Lee's home in Virginia. Other businesses soon followed and, in 1880, the population totaled 275 people. Despite being a Western settlement with cattle trails on each side and the occasional shootout, residents began the process of building a town with schools for their children and churches for their families.

Middleton Tate Johnson

Mexican War veteran Middleton Tate Johnson's service earned him a land grant near Marrow Bone Springs, where he had established a Ranger post in 1846. He established a cotton plantation called Johnson Station—a frontier outpost with a stagecoach stop, general store, and post office. Politically active, Johnson served in the Congress of the Republic of Texas and made several unsuccessful bids for governor. Johnson, with other prominent residents, managed to persuade the Texas legislature to create a county out of a portion of northern Navarro County. On December 20, 1849, Gov. George T. Wood signed a bill creating Tarrant County, named after Mexican War general Edward H. Tarrant. Hand-drawn by Tarrant County Judge C.C. Cummings, this 1849 ink and linen map of Tarrant County features rivers, landmarks, and early towns such as Johnson Station, later part of Arlington.

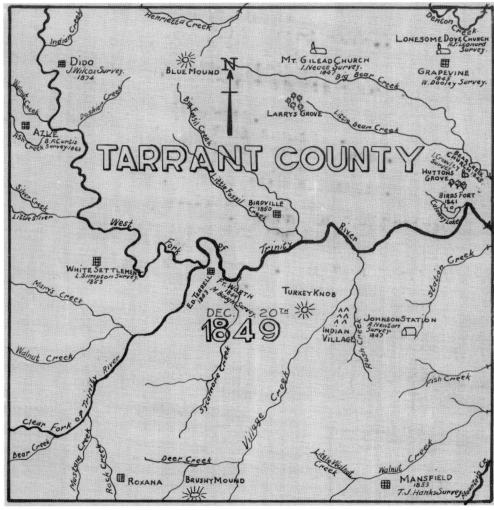

Zachary T. Melear

Farmer and blacksmith Melear and his bride Jane Catherine Jopling were among the early pioneers who settled Johnson Station. Jane's father, George Washington Jopling, built the cabin behind the young family in this undated photograph and deeded it to his daughter. The Arlington Historical Society preserved the original cabin, the right side of the structure, and moved it to Knapp Heritage Park, located on West Front Street.

Rev. Andrew Hayter

Presbyterian preacher Hayter and his family settled in the Watson Community, an area now part of the Six Flags Over Texas theme park. Hayter surveyed the route for the Texas and Pacific Railway Company through the area in 1876. There is a dispute as to whether it was Hayter or James Ditto Sr. who named the new town after Arlington, Virginia, the home of Robert E. Lee. (Courtesy Evelyn Barker.)

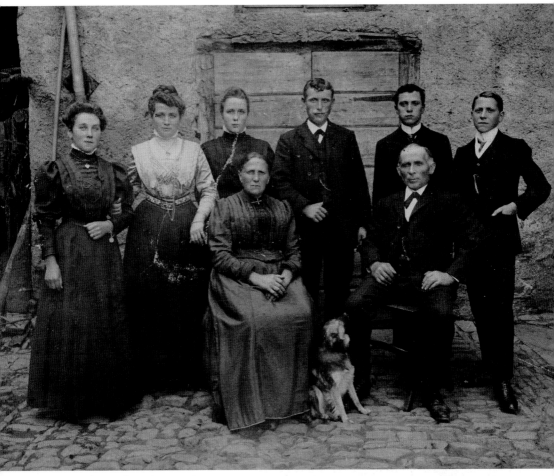

Henry George Lampe

German-born Lampe established one of Arlington's first businesses after the railroad surveyed the town site in 1876. His shop on the corner of Center and Abram Streets resounded with hammer on anvil as he worked on farm equipment. Like many merchants in the small town, he had several small side businesses in order to support his growing family. The local newspaper reported years later that he worked 42 years without taking a vacation. Shown in this 1912 family portrait are Henry and his wife, Lena, seated in front, with their children (from left to right) Alma, Anita, Pauline, Henry, Will, and Fred standing behind them.

John W. Ditto

John Ditto and his brother James were early businessmen in Arlington and contributed to the pioneer town's growth. The Ditto and Collins Land Company owned by John Ditto and Archibald W. Collins provided the land for Arlington College. The school was the first of many institutions that eventually became the University of Texas at Arlington.

William C. Weeks

William Weeks built the Arlington Light, Power, Ice, and Water Co. at Center and South Streets in 1909. Businesses in the growing town soon had electric fans blowing cool air on grateful customers. Weeks was also involved in local banking and a brick business. During his term as mayor (1900–1902), he fought to improve the public school system and establish the interurban line through town.

Rice Woods Collins

Merchant Rice Woods Collins is notable for a beloved landmark in Arlington: the old mineral well at Center and Main Streets. Collins saw the need for a public water supply and started a public subscription to drill a well in the center of town. The contractors finished drilling in 1893. Much to the dismay of the populace, the water was not ideal for drinking. Over the years, the mineral water cascaded from a variety of fountains as styles and needs changed. Throughout the first part of the 20th century, the mineral well was a favored meeting place to exchange news and observe passersby.

James P. Fielder

Like many of Arlington's early settlers, James Park Fielder was born in another state and moved to Texas after the Civil War. Initially settling in Fort Worth, Fielder and his wife, Mattie, moved to Arlington, where the couple welcomed the community to their landmark home on the hill near the interurban line. Their son, Robert Fielder, recalled that visitors often sat on the east porch with tea and refreshments. When they were ready to leave, his father would go down to the cellar, which was full of bushels and baskets of produce from their 215-acre farm, and select a gift to bring up for them. James served as mayor of Arlington from February 11, 1909, to April 8, 1909, and was an original board member of North Texas Agricultural College, now the University of Texas at Arlington.

Mary Carlisle Cravens

It is doubtful that Mary Carlisle knew when she moved to Arlington in 1902 that she was beginning a 30-year career as a Texas educator and would help found an organization that would contribute significantly to the lives of Arlington residents. She started teaching at Carlisle Military Academy, owned by her father, Col. James Carlisle. In 1904, she founded the Carlisle-Smith Institute, a girl's school, with Margaret Smith. Regrettably, it closed after the first year. Carlisle was a founder and charter member of the Shakespeare Club, organized in 1908. Initially formed to study Shakespeare, the organization soon became a force for progress. In 1911, the club helped found the Arlington Forum, the first parent-teacher organization, the Arlington Art Association, and the Arlington Library. After the 1921 death of her husband, Dr. Milton H. Cravens, she returned to teaching.

Dr. Milton H. Cravens

Milton Cravens earned his medical degree in Louisville, Kentucky, and moved to the Johnson Station area of Arlington in 1885. After his wife, Betty Burney, died, he married Mary Carlisle, the daughter of James Carlisle. Cravens purchased one of the first two automobiles in Arlington in 1898 to help him in his rural practice. He practiced medicine in Arlington until 1916.

Frank and Charles McKnight

Pioneer businessmen Frank and Charles McKnight felt north Texas had a future when they moved to Johnson Station in 1869. After the railroad arrived, they relocated to Arlington where Frank established a general store while Charles went into the grocery business. By 1915, Frank was the president of the newly organized First State Bank of Arlington. Pictured here in 1915 is McKnight Grocery Store with, from left to right, unidentified, Clem Coble, Charles's son Ed McKnight, and Smoky Kelly.

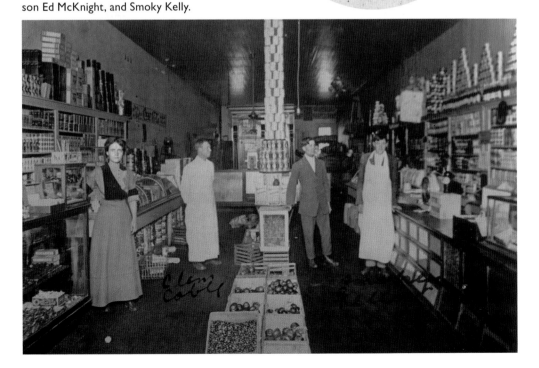

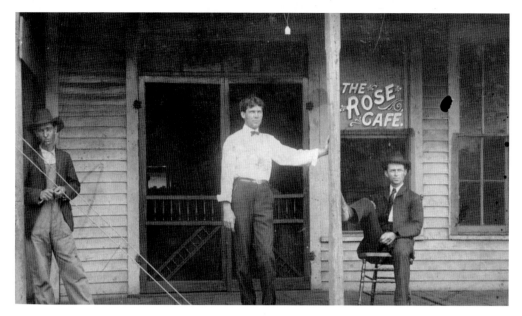

William H. Rose

William Rose (above, center) and his brother Webb (not pictured) were partners in the Rose Brothers Realty Company. Rose won the mayoral election on October 1, 1919, and with the commissioners, made many significant changes during his term. Arlington's first city charter was adopted in 1920, the first sidewalks were laid, a new water system established, and new businesses were formed.

At this time, Arlington was flourishing and enjoying the benefits of the interurban line that connected the town with Fort Worth and Dallas. The interurban line was a light railway service that specialized in passenger travel between closely spaced communities. It was possible to leave every hour from 6:00 a.m. to 11:00 p.m. from the interurban station (in the upper center of the photograph below) and arrive in Dallas within 45 minutes.

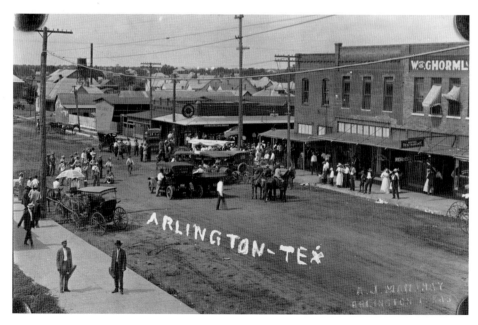

CHAPTER TWO

Movers and Shakers

The members of Arlington's chamber of commerce were mistaken in 1953 when they drafted the city's five-factor plan featuring agriculture, residences, industry, services, and education for creating an attractive and prosperous city. Significantly, their list was missing a vital element: Arlington's residents, who in the end transformed a sleepy farm town of a little more than 7,600 residents into a bustling metropolis and major entertainment destination. Strong political leadership—such as Mayor William Barrett's guiding hand during the Great Depression when the city was threatened with a fiscal crisis, and Tom Vandergriff's dynamic introduction of a General Motors assembly plant, a Major League Baseball franchise, and Six Flags Over Texas—created an environment conducive to growth. Other residents were role models who opened up opportunities for minorities in the political realm. In 1914, Carrie Rogers was the city's first female chief of police during a time when women could not vote. Martha Walker became the first female City Council member in 1972, and Elzie Odom was elected as the first African American mayor in 1997. Charitable and spiritual leadership enriched residents' daily lives. In 1903, the Rev. James T. Upchurch and his wife, Maggie, established a home for "erring girls" that provided moral and financial support in creating a new life. They were only two of many benefactors throughout the years. Families benefitted from the commitment of Dottie Lynn, who founded Arlington's YMCA, which provides childcare for schoolchildren. The homeless and underprivileged are indebted to Sylvia "Tillie" Burgin, who organized Mission Arlington—a source of free medical clinic services, job training, crisis counseling, and day shelter facilities to those who need them. The environmental activism of Julia Bergen, who fought to preserve the natural landscape of Johnson Creek, saved crucial green space for the future. Tom Vandergriff, mayor throughout much of the city's dynamic growth, was correct when he credited the people of Arlington and their positive spirit for its success.

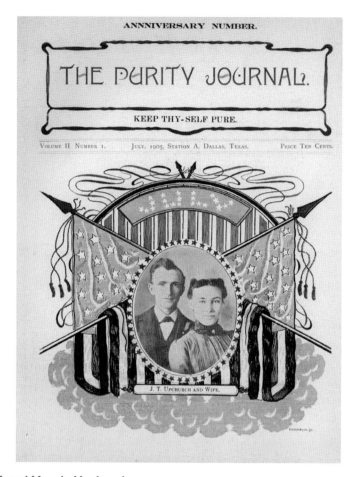

ANNNIVERSARY NUMBER.

THE PURITY JOURNAL.

KEEP THY-SELF PURE.

VOLUME II. NUMBER 1. JULY, 1905, STATION A, DALLAS, TEXAS. PRICE TEN CENTS.

J. T. UPCHURCH AND WIFE.

Rev. James T. and Maggie Upchurch

Rev. James T. Upchurch and his wife, Maggie May Adams, were partners in a lifelong mission to share their deep Christian faith and help those less fortunate. Early in their marriage, they felt called to rescue young women from red-light districts. Their first mission was in an empty room over a saloon in Waco. After meeting resistance from the community, they relocated to Oak Cliff near Dallas. Upchurch began searching for a place to build a home for "erring girls" where they could have moral and financial support in creating a new life. He wanted a place away from saloons and their wicked influence. He found the ideal place in Arlington and purchased seven acres from James D. Cooper. In 1903, Reverend Upchurch dedicated the Berachah Home for the Redemption of Erring Girls. The white, two-story dormitory offered shelter to 60 women and girls during its first year. As much as possible, Upchurch designed the home to be self-sustaining, with a garden, handkerchief factory, and print shop. Work in the home's handkerchief factory improved the women's prospects and supported the home's mission. The Berachah Home eventually became a refuge for unwed mothers, where the girls were encouraged to keep their children and learn how to care for them. Reverend Upchurch never regarded the girls and women as sinners but attempted to change the environment that led to their downfall. Nor did he regard the 100-plus children born in the home as illegitimate. Throughout his ministry, Reverend Upchurch focused upon fundraising to support the home. He published the *Purity Journal*, which campaigned against vice, promoted the home, and raised funds. As attitudes toward unwed mothers changed and the Great Depression continued into the 1930s, public support diminished until mounting debts forced the home to close in 1935. The Upchurches moved to Oak Cliff and carried on their rescue work in jails. James died in 1950, and Maggie followed him in 1963.

Carrie Coleman Rogers

Carrie Coleman Rogers was a leader, trendsetter, and role model for Arlington women in the first half of the 20th century. Born in Virginia in 1861, Carrie arrived in Texas with her grandfather in 1873. She married Andrew Jackson "A.J." Rogers, a wealthy merchant, in 1883 and became a social leader in the town. Carrie was known not only for her large, lavish parties but also for her social work. She contributed to environmental and public health causes, continuing education for the public, and issues relating to women and African Americans. After her divorce from A.J. in 1902, Carrie turned to real estate to help support herself and to address what she saw as a lack of adequate housing that was holding back Arlington's growth. In 1914, Rogers made headlines across the state as Texas's first female city marshal. She was nominated to this position because of her many years of effort regarding civic reform. Carrie used her new position to improve the city, particularly from a moral perspective. She held the position for only two months before the mayor and city commissioners dismissed her. The reason is unknown. She continued to flourish in real estate and was active in the city's life for decades. She died in Arlington in 1947.

William L. Barrett

Minister and feed store owner William L. Barrett served as mayor during the Great Depression and some of Arlington's most financially trying times. His 1933–1935 term was eventful because Arlington had a bond issue due and the city could not make the payment. Fortunately, the bondholders granted the city an extension and lowered the interest rate from six to four percent. The bondholders received 85 cents of every dollar the city took as revenue.

Barrett was in office when pari-mutuel betting became legal in Texas. During racing season, the cars came through Arlington bumper to bumper, and race fans packed the Arlington Downs grandstands. He recalled that "life wasn't a bed of roses" after people could place bets at the racetrack—the area was so broke that it was common for eight men to get together and put in 25¢ each in order to buy a $2 ticket.

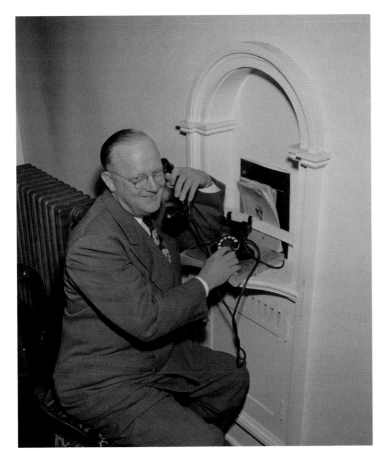

Barney Carl Barnes

B.C. Barnes came to Arlington in 1929 to teach business at North Texas Agricultural College. He served in the US Army Air Forces during World War II, then returned to Arlington and became the registrar at NTAC.

While continuing to be employed by the college, Barnes was elected mayor of Arlington in 1947 after running on a "Good Government" platform. During his term, Barnes oversaw one of the most significant changes to the town's communications system: the introduction of dial telephones in December 1949. Previously, callers picked up the phone and spoke to an operator, or "Hello Girl," who connected the phone call. The new direct-dial phones made operators obsolete.

Arlington was one of the first cities in the United States to get the dial system, and local newspapers carefully explained how to use the phone: "Place the receiver to your ear and listen for the steady hum of the dial tone. Pull the dial around clockwise until your finger strikes the finger stop. Remove your finger and let the dial spin back freely. If you hear the busy signal . . . Hang up, and after a few seconds' wait, try the call again."

Mayor Barnes is shown here making the first dial telephone call in Arlington to his friend R.F. Binney immediately after the new phone system went into effect at midnight. The *Arlington Journal* reported the conversation as follows: Barnes, "Hello." Binney, "Hello, what? It's midnight. Who is this?"

Barnes was succeeded as mayor by Tom Vandergriff in 1951. Except for his military service, which included being recalled to service for the Korean War, he continued working at NTAC, then Arlington State College, and finally the University of Texas at Arlington from 1929 until his retirement as vice president for administration in 1969. Barnes was also active in the Rotary Club, the Arlington Chamber of Commerce, and the Presbyterian Church. He died in 1983.

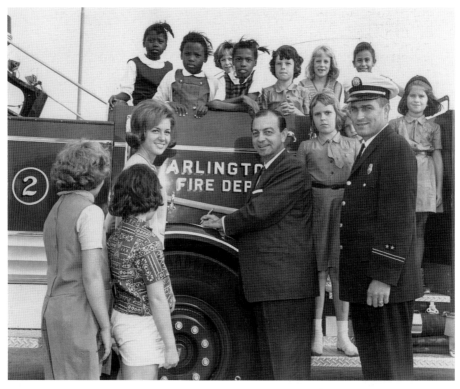

Tom Vandergriff

On March 24, 1961, the *Dallas Morning News* printed a brief but revealing article on Arlington Mayor Tom Vandergriff:

> Tom J. Vandergriff, mayor of Arlington, recognized J.R. Shiflett, minister of Abram Street Church of Christ, to present a little petition to the city council. And that's where His Honor got the surprise of his life. The petition said that one Tom J. Vandergriff had worked day and night at his mayoring job, that he was tireless, that he was unselfish, that he was the best of mayors and whereas and therefore the signers petitioned the honorable city council to vote to said Tom J. Vandergriff an annual salary of $25,000. (Vandergriff has served Arlington 10 years at $10 per month.) "I don't want a salary," said His Honor. "And if it is offered, I wouldn't accept it. But it is the most heartwarming gesture ever directed at me." But on one point there is no question. Vandergriff is worth the money. No city ever had a more dedicated mayor.

Vandergriff was only 35 when Shiflett made his petition and the *Morning News* its pronouncement, and neither could have guessed at the great things Vandergriff was yet to accomplish. But the article makes clear that Vandergriff had earned the town's love and respect and that his impact could already be felt in the region. It also shows Vandergriff's character. The office of mayor was not supposed to be a full-time job, but Vandergriff turned it into one and did it without the expectation or motivation of greater wealth. He is shown here (center) with Fire Marshal J.W. Dunlop at right and Arlington children in 1965. He served as mayor for 26 years. When he announced that he was stepping down in 1977, the town was shocked. An entire generation had grown up only knowing Vandergriff as mayor—including his own children. He did not retire from public life, however. He served as a US representative from 1982 to 1984 and then as Tarrant County judge from 1990 to 2006. But being the mayor of Arlington was always closest to his heart. In a 2006 interview with the *Fort Worth Star-Telegram*, Vandergriff said, "The best job I ever had paid me $10 a month." Vandergriff died in 2010.

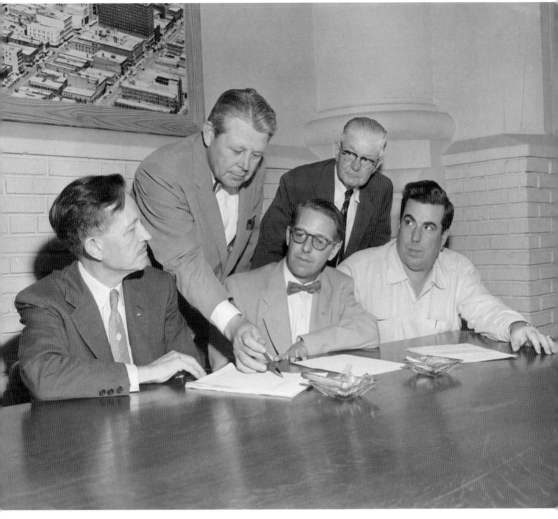

James "Big Daddy" Knapp

James Knapp bought land in Arlington long before real estate in the small city became valuable. He was the first president of the Arlington Bar Association and, as a lawyer, gave his time freely to those who needed it. Knapp was active in Tarrant County politics, and it was rumored that his support was essential for prospective office-seekers. Considering the advantages of developing Watson School Road, now Texas 360, as a key highway connection at this 1955 meeting are, from left to right, (first row) Charles A. Stewart, Charles McNeese, and James Knapp; (second row) Olen S. Dobkins and Otis Fowler.

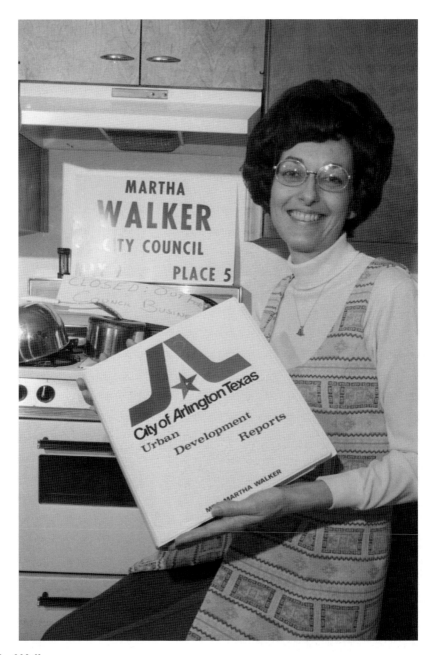

Martha Walker

Martha Walker decided to run for city council in 1972 at the urging of her bridge club. "It was a year that for the first time there was a lot of emphasis on women in public office," Walker said in a 1983 *Dallas Morning News* interview. "I eventually ran because I was interested in serving the council, not just because I was a woman." She was the first woman ever to be elected to the council, and she served for 10 years. She is shown here in 1973. During her tenure, she was notably involved with the creation of the Fielder Museum and the East Arlington Renewal project. "If somebody can do the job, give them a chance—whether they're a man or a woman," Walker told O.K. Carter in a 1999 *Fort Worth Star-Telegram* interview.

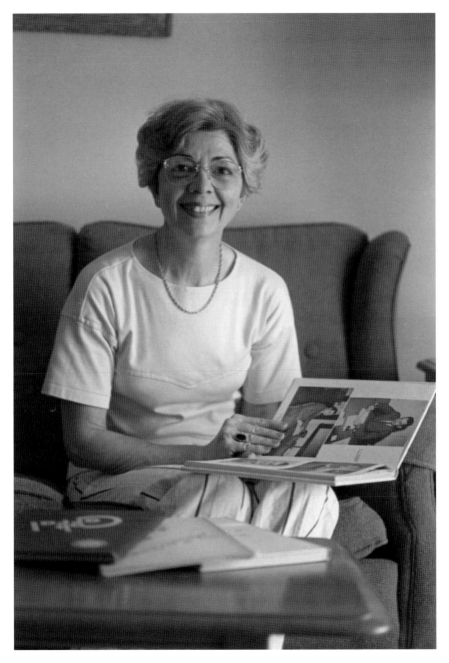

Dorothy Rencurrel
Dorothy Rencurrel found time in 1980 to reflect upon the time that her mother, Margaret Thornton, and other PTA members defied the school district's plan to chop down trees to build the Kooken Elementary School at Center and Sanford Streets in 1936. Needless to say, the protesters, wearing pillbox hats and gloves, persevered, and the school district left the trees on the lot. Today, Rencurrel, a descendent of Arlington mayor William C. Weeks, devotes the same energy to preserving the history of Arlington. She heads or supports a long list of civic organizations, such as the Arlington Historical Society, the Landmark Preservation Commission, and the Friends of the Arlington Public Library.

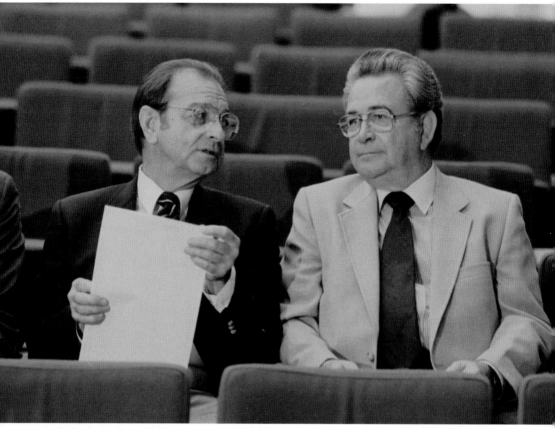

S.J. Stovall

When Tom Vandergriff (left) resigned as mayor in 1977, the city was shocked. No one had seen it coming, least of all mayor pro tem S.J. Stovall (right). Stovall was in San Francisco when his wife called to tell him that Tom had resigned. "So help me," Stovall recalled in a 2001 *Fort Worth Star-Telegram* interview, "I said 'Tom who?' " Upon Vandergriff's resignation, Stovall became mayor, a position he held until 1983. According to a 1981 *Star-Telegram* interview, Stovall knew that he had to forge his own path. "I tried to make the point that Arlington was entering into another period in its life. . . . I would be a completely different type of mayor." Stovall is credited with leading the city through the financial backlash caused by the failure of the city-owned Seven Seas Park. He died in 2010.

Kenneth Groves

Labeled a maverick, Groves forever changed Arlington's city council. Elected to the council in 1978 with his defeat of Richard Greene, he went public with issues that council members often kept among themselves. Here, he proudly shows off a Christmas tie with the Arlington city logo. He worked as an engineer and surveyor. As a devout Baptist, he befriended Mount Olive Baptist Church and extended his surveying expertise to the African American community.

Elzie Odom

After a distinguished career in the US Postal Service, Odom (left) launched a successful bid to become the first African American to serve on the Arlington City Council. He worked on minority issues and labored to keep the General Motors Automobile Assembly Plant in Arlington. In 1997, he successfully won a close election for mayor. His 1997–2003 tenure saw a renewed interest in the revitalization of downtown Arlington.

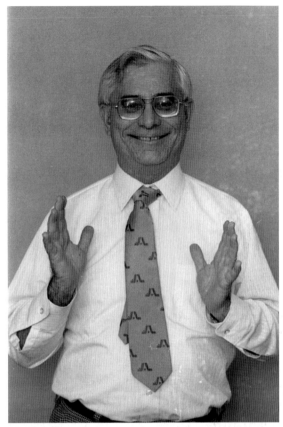

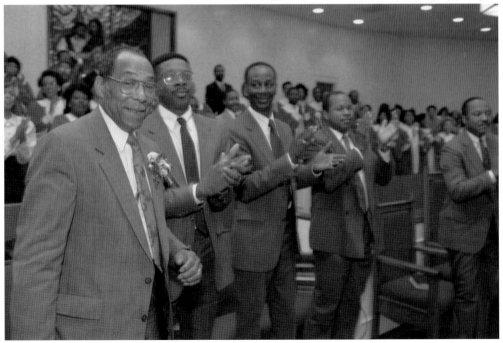

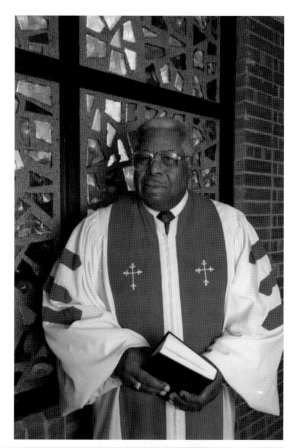

Rev. Norman L. Robinson

Reverend Robinson began his ministry at Mount Olive Baptist Church in 1966 with a congregation of only 17. Today, the church is flourishing, with more than 10,000 members. Mount Olive Baptist Church, established in 1897, is the heart of the African American community, located in the approximately five-block area known as The Hill. Under Robinson's guidance, the congregation created the Metro Christian Academy (now Metro Charter Academy), the Mount Olive Credit Union, the Arlington New Beginnings elderly housing project, and other community programs. The church also successfully supported the candidacy of Elzie Odom for Arlington City Council and mayor. In July 1992, Arlington renamed North West Street, north of Division Street, N.L. Robinson Drive.

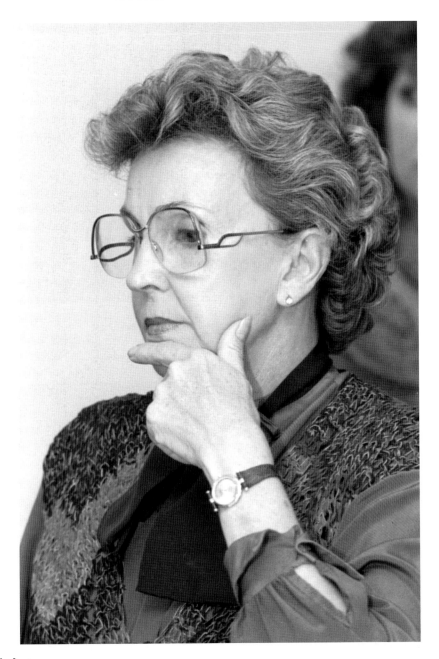

Dottie Lynn

"It was a great day when Dottie Lynn came our way," said former mayor Tom Vandergriff in a 2000 speech. Dottie Lynn and her family were but three of the thousands who moved to Arlington in 1952, but Lynn stood out because of her relentless energy and drive. In 1958, she helped open Arlington's first YMCA. In 1966, she was among those who launched Arlington's popular Fourth of July parade. Lynn won a seat on the city council in 1982 and stayed until 2000. While on the council, she fought through breast cancer and a brain aneurysm. Her signature achievement was spearheading the construction of the western loop of Green Oaks Boulevard, which was named for her in 1994. One of her greatest regrets was not bringing public transportation to Arlington. Lynn, shown here in 1987, died in 2006.

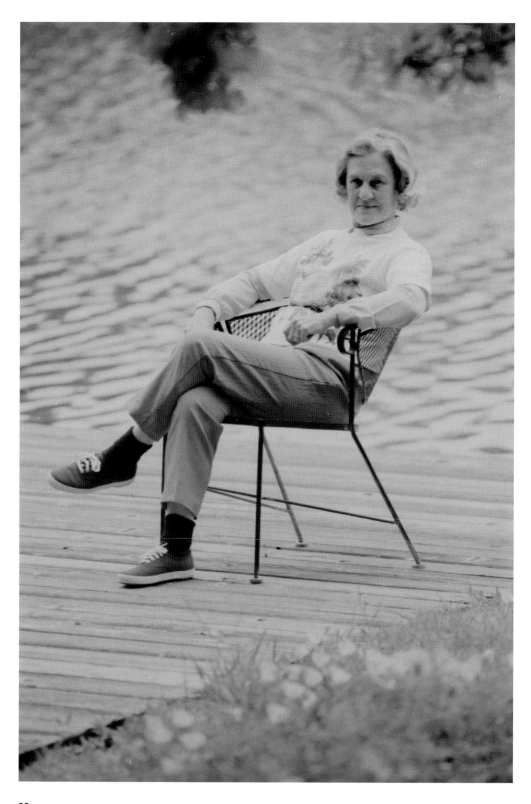

Owen Kelton Carter

Columnist and editor O.K. Carter started with the *Arlington Citizen-Journal* in 1972 and retired from the *Fort Worth Star-Telegram* in 2008. Through his career, Carter has interviewed hundreds of Arlington residents and has written thousands of columns about Arlington's past and present. His love and interest in the city has made him, in his own words, the "unofficial historian" of Arlington. He is married to fellow Arlington writer Donna Darovich.

Sylvia "Tillie" Burgin

Sylvia Burgin, known by all as Tillie, is the moving force behind Mission Arlington. Mission Arlington has a profound impact on the community, offering a medical clinic, job training, crisis counseling, day shelter, and summer camps for inner-city children. In one month, approximately 5,400 families receive clothing, food, utilities, transportation, and furniture.

Julia Burgen (OPPOSITE PAGE)

Julia Burgen has lived, in her own words, "seven-plus" decades. But time has never diminished her drive to fight for the environment. "I do not want to go to my grave and leave a damaged planet and one in which others have to breathe bad air," Burgen said in 2011. One of her many notable fights has been to preserve Johnson Creek. "From 1989 on I became concerned about problems along Johnson Creek caused by longstanding failures to keep development out of the floodplain," Burgen wrote in 2006. To the *Fort Worth Weekly* in 2007 she said, "There is something about a wild creek that bespeaks things much larger than we are." The Julia Burgen Linear Park, an undeveloped section of Johnson Creek, was dedicated in 2004.

Richard and Sylvia Greene

Arlington historian O.K. Carter once compared former mayor Richard Greene's attitude toward Arlington to that of a lion protecting its turf. Richard showed the truth of that comment when, in 1994, he famously growled that Arlington was "not anybody's damn suburb." As mayor (1987–1997), Richard led the effort to get The Ballpark in Arlington built, replacing the aging Arlington Stadium. After leaving office, he began teaching in the School of Urban and Public Affairs at UT Arlington. Richard's wife, Sylvia Greene, served as the first president of the River Legacy Foundation, which provides "funding for the preservation and expansion of River Legacy Parks," according to its website. "[To] me preserving nature is a very spiritual thing," Sylvia said in a 1996 *Fort Worth Star-Telegram* interview. "God is in nature, always. We have a responsibility to the environment."

CHAPTER THREE

Enterprise and Endeavors

Created in 1876 by the Texas and Pacific Railroad as a stop for fuel and water, Arlington's humble beginning included a tent for a railroad station and three small businesses set up by local merchants. The settlement's economy initially relied on cotton and grain. Growth was slow and steady. In 1901, farmers shipped 12,000 bales of cotton, 100 cars of wheat, and 50 cars of corn from the loading dock of the newly built station.

On market days, farmers loaded their wagons with goods from E.E. Rankin Grocery and window-shopped along the wooden sidewalks on Center and Main Streets. Unexpectedly, events in the 1950s rocketed the sleepy town into the role of a thriving, vital metropolis and entertainment destination. Several prominent businessmen and the new mayor, Tom Vandergriff, aggressively campaigned for residential and industrial growth. General Motors decided to build a plant in Arlington in 1951, and the chamber of commerce convinced Oil States Industries to relocate from Grand Prairie to Arlington. During that dynamic decade, the population soared from 7,692 to 44,775. Happy King and James Knapp sold homes to workers attracted to the growing city by the GM plant and soldiers returning from World War II.

There were more changes to come. Angus G. Wynne Jr. developed the Great Southwest Industrial District, a master-planned industrial area. In an effort to bring in funds for the business park's infrastructure, Wynne built a theme park similar to Disneyland in California. Opening in 1961, Six Flags Over Texas was a huge success, with more than 500,000 visitors during the first short season of 45 days. A major tourist attraction, the park inspired other projects. The city would eventually host two major sports teams, the Texas Rangers and the Dallas Cowboys, and the Hurricane Harbor water park. Vandergriff felt that Arlington would fare well in the 20th century. "I could envision lightning striking suburban America, and Arlington in particular," he explained when describing the city's success.

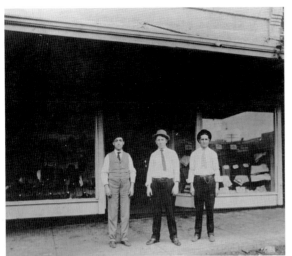

Charles Brower and Ray McKnight
Spanish American War veteran Charles Brower felt that the start of the 20th century would bring dizzying opportunities when he arrived in Arlington right after the war to go into business with Ray McKnight. Standing in front of the Brower-McKnight Menswear store window in 1908 are, from left to right, Charles Brower, Henry Williamson, and Ray McKnight. Brower later went into the dry cleaning business while McKnight continued in the menswear business until the 1940s.

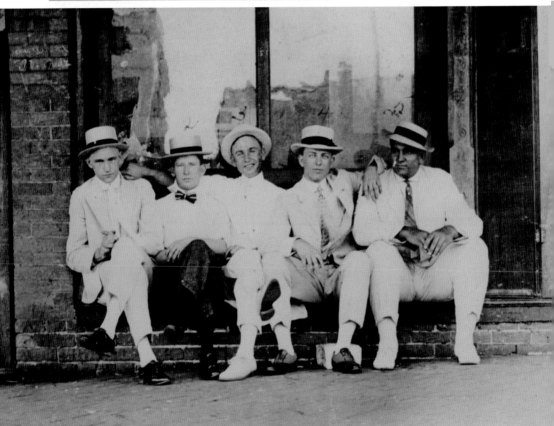

Benton Collins
In 1915, Benton Collins, grandson of Civil War veteran and early Arlington mayor Thomas Benton Collins, posed with four friends in front of a store. Dressed in summer white, from left to right, are Benton Collins, Ed McKnight, Loyd Hutchinson, Henry Williamson, and Robert Rankin. The young clerks and merchants enjoyed a brief respite during the days before America entered World War I.

Col. William A. Bowen

Newspaper editor and author Bowen purchased the local *Arlington Journal*, predecessor to the *Arlington Citizen-Journal*, in 1907. He updated the print shop with a Linotype press and typesetting machine. He wrote *Chained Lightning*, *Why Two Methodist Churches in the United States?* and *Uncle Zeke's Speculation*. This undated photograph shows him standing in the center of the room wearing a dark suit.

George W. Hawkes

George Hawkes was known for the way he balanced reporting local news with articles supporting the community. He purchased the *Arlington Citizen* in 1946 and eventually merged it with the *Arlington Journal*, creating the *Arlington Citizen-Journal*. He later sold the paper to the *Fort Worth Star-Telegram*. He commented during the ceremony naming the city's main library after him, "Written words are still powerful persuaders."

Col. Thomas Spruance

Arlington offered opportunities for entrepreneurs who were willing to invest time and money in developing businesses. Spruance was active in several local businesses. Over the years, he owned a lumberyard and a grocery business, was a grain dealer, and financed a weekly newspaper called *The World*, published by Willis M. Timmerman. He was president of the Citizen's National Bank and served as the postmaster in 1886.

Lillard Stock Farm

The Lillard family moved to Arlington from Seguin in 1920 and founded one of the largest hog farms in the country. George P. Lillard's hogs were known as champions across the United States and won many honors at livestock shows and fairs. The stock farm stayed in business until around 1971.

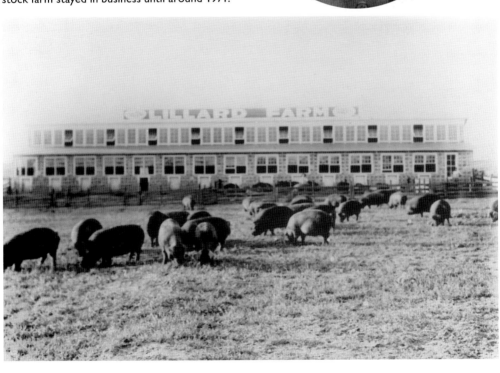

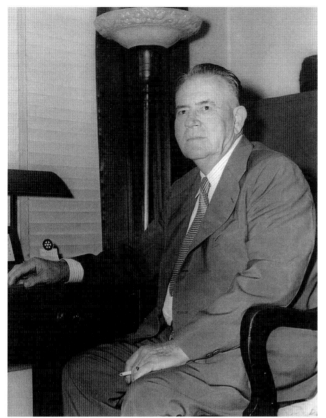

Hugh Moore

In 1910, Moore (left) established Hugh M. Moore Undertakers in a furniture store where furniture and caskets were sold up front and mortuary services were located in the back. Moore was elected justice of the peace in 1922 and mayor for a two-year term in 1925. As the business grew to include ambulance services, the name changed to Hugh M. Moore and Sons Funeral Homes to reflect the addition of Moore's sons Harry, Bob, and Howard. The 1928 photograph below features the funeral home's fleet of ambulances and funeral cars, which at one time included a purple hearse. Today, Watson Frazar, president and manager of Moore Funeral Home, is continuing what the Moore family began.

Oscar S. Gray Nursery

When O.S. Gray moved to Arlington in 1926 to teach agronomy at North Texas Agricultural College, he bought 46 acres to plant pecan trees to give his students hands-on experience. He visualized new varieties of pecans and the development of new farming practices that increased pecan production. He soon quit teaching and opened O.S. Gray Nursery, where growers and homeowners could purchase GraKing, GraZona, and other varieties of pecans that he developed. Arlington celebrated his accomplishments with the opening of O.S. Gray Park in 2010.

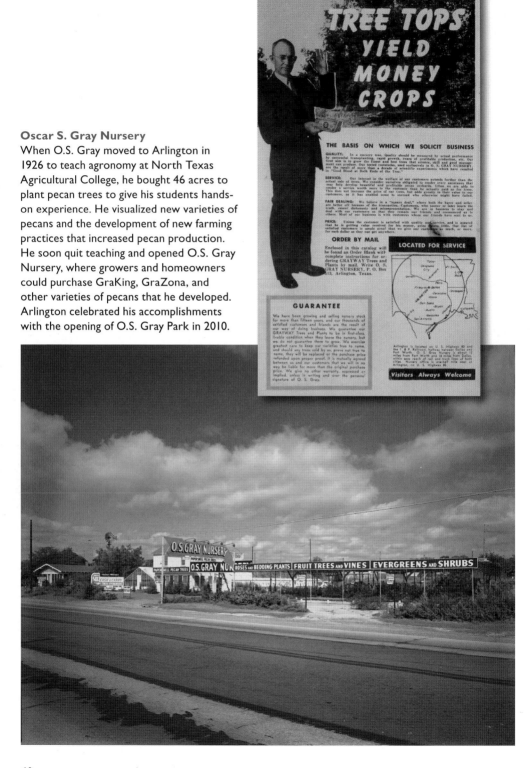

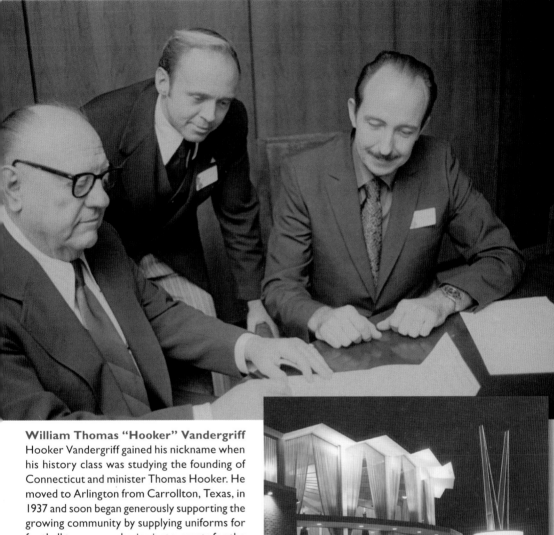

William Thomas "Hooker" Vandergriff
Hooker Vandergriff gained his nickname when his history class was studying the founding of Connecticut and minister Thomas Hooker. He moved to Arlington from Carrollton, Texas, in 1937 and soon began generously supporting the growing community by supplying uniforms for football teams, purchasing instruments for the Arlington High School band, and donating land for Arlington Memorial Hospital. Above, from left to right, Hooker Vandergriff, Bob Rundell, and Tom Morrissey celebrate Vandergriff's donation of five acres to Arlington's YMCA. He first established a Chevrolet dealership at Center and Division Streets and then relocated a few blocks to the corner of Collins and Division Streets, where the trademark "V" welcomed buyers (right). Decades later, Vandergriff—now a family business with five dealerships—moved to the Interstate 20 corridor, where it remains.

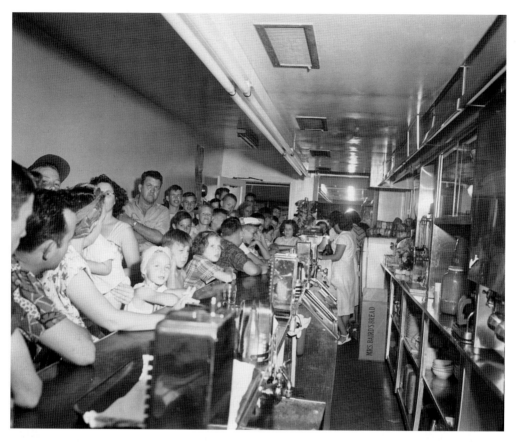

Rockyfeller Hamburgers

Sandwiched between two larger buildings on Main Street, Arlington's Rockyfeller Hamburgers, shown here in 1953, was a favorite late-night hangout for residents. The small restaurant contained one long counter with stools and a booth at the back. Diners could eat their Rocky Burger with special Rocky Sauce and a large plate of fries on the side, perhaps served by a young J.W. Dunlop who worked at the restaurant when he came to Arlington in 1939.

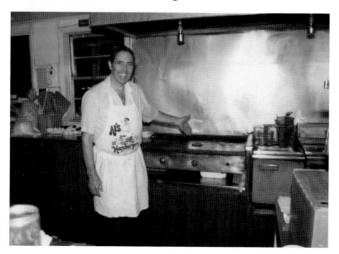

Al's Hamburgers

When Al and Thelma Mathews opened Al's Hamburgers on Collins Street in 1957, the location was so remote that Al frequently had to shoo cows off the drive-in parking lot. Development forced Al's to close in 1986, but it reopened farther north in 1989. Al is shown in 1982 with his vintage 1948 griddle for which, he says, he paid $45. (Courtesy Lawrence family.)

Candlelite Inn
Candlelite Inn opened in 1957 and was noted for its romantic booths and eclectic fare. Diners could choose from steaks, Mexican food, or Italian cuisine. Booths featured swinging doors and a tabletop jukebox. Original owner Robert Keith opened the Candlelite Inn on east US 80 to take advantage of the potential clientele at what was then the recently opened General Motors plant.

Arlington Steak House
Arlington Steak House opened in 1931 as the Triangle Inn on busy US 80 (now Division Street). With Arlington Downs at one end of US 80 and the Top O' Hill casino at the other, many Depression-era high rollers like Bugsy Siegel stopped at the Triangle Inn to eat and get up a game of poker. The restaurant was renamed Arlington Steak House in the 1940s and remains in operation.

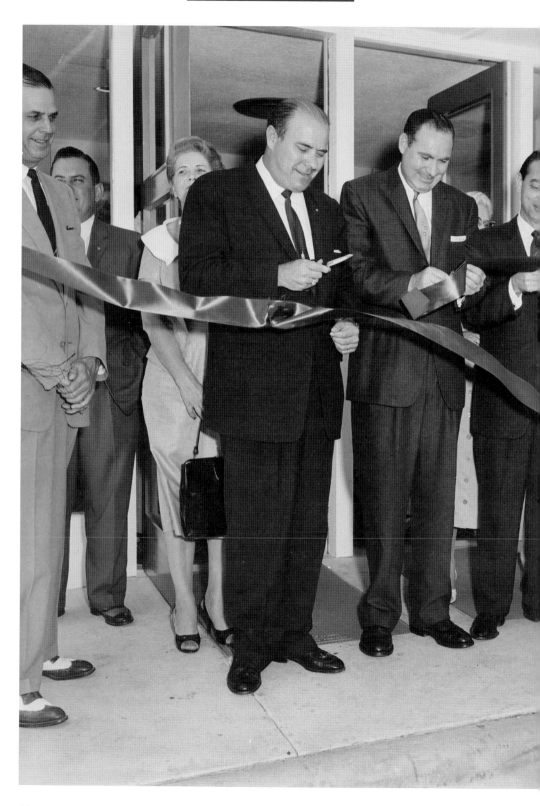

Great Southwest Industrial District

From its beginning in 1955, Angus Wynne's Great Southwest Industrial District (GSWID) was designed to be the biggest and best industrial park in the United States. Wynne, already well known for developing the Wynnewood community and Wynnewood Shopping Village in Oak Cliff, Texas, and soon to be better known for Six Flags Over Texas, imagined GSWID as a clean, modern facility with no "heavy industry or factories causing bad odors." In 1957, plans for the district included a $1 million bowling alley, a 100-acre sports center, restaurants, office buildings, and hotels. Though the sports center did not materialize, Great Southwest did build a 32-lane bowling alley. Emphasizing GSWID's regional importance, officials from five nearby cities cut the ribbon to Great Southwest Bowling Lanes in 1958. From left to right are Fort Worth mayor Tom McCann, Hurst city manager Clifford Johnson, Arlington mayor Tom Vandergriff, Grand Prairie mayor C.R. Sargent, Dallas councilwoman Calvert Collins, and Bedford Wynne, secretary of Great Southwest Lanes.

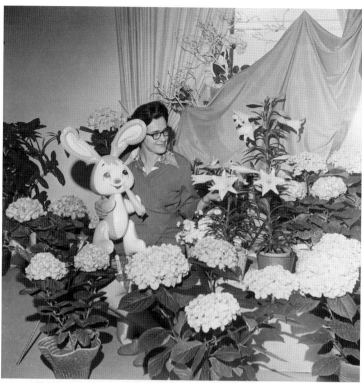

H.E. Cannon Floral
Originally begun in Tyler, Texas, in 1893, Horace Cannon's floral business moved to Arlington in 1921. The business has occupied the same Division Street location for more than 90 years and is still family-owned. Lena Faye McCarter, granddaughter-in-law of Horace Cannon, poses with Easter flowers in 1971. She worked for the company from age 18 until she retired at 83.

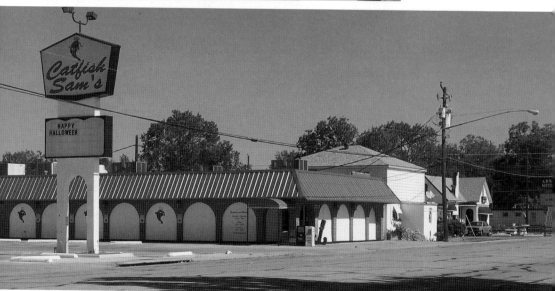

Catfish Sam's
Catfish Sam's started life in 1952 as La Casita. Born in Gainesville, Texas, Sam and Jo Dale Lester moved to Arlington in 1947 after Sam left the Merchant Marines. They opened La Casita next to Lester's Motor Inn, owned by Sam's parents. After nearly 30 years in business, Sam and Jo Dale built a new restaurant next door and changed to a catfish menu in 1991. Sam died in 2007 and Jo Dale followed in 2012. The business is now run by their daughter and her family. (Courtesy Evelyn Barker.)

Honeycutt E. and Burney Pearl Caton
Honeycutt E. and Burney Pearl Caton founded Fluffy Ruffling Manufacturing Company in the 1920s, producing dress trims, ruffles, and lace on the second floor of a building across from their Center Street variety store. In the early years, Honeycutt (shown in the undated photograph to the left) traveled by bus through 15 states as a "drummer" (traveling representative) for their factory. By 1942, the business expanded to manufacture children's dresses of Burney's design. The venture that began with just two machines and two employees grew to become one of Arlington's largest industries, employing 50 individuals operating 65 machines. In the undated photograph below, Pat and Becky Sparks model Fluffy Ruffling dresses. The company marketed its products to wholesalers and retailers throughout North America, including Macy's, Sears, and F.W. Woolworth. The Catons sold Fluffy Ruffling in 1964 and closed the variety store in 1969.

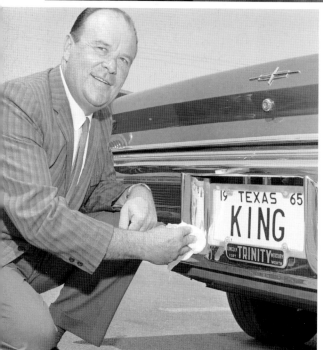

George Elston Luttrell

Born in Georgia, George and his brother, James Moreland, went into the grocery business in 1900. Luttrell's Grocery on Center Street was part of a vital downtown business district. Luttrell also managed the interurban depot at Abram and Center Streets and served on the city council from 1921 to 1925.

Wilson "Happy" King

Happy King, real estate agent, polishes his new license in 1965 after the state started issuing special tags. In 1954, King, an active member of Arlington's chamber of commerce, was part of the committee delegated to study the lack of a hospital in Arlington. The Happy King subdivision near Cowboys Stadium is a reminder of his contributions to the city's growth. Happy King Investments continues with his daughter, Kay King.

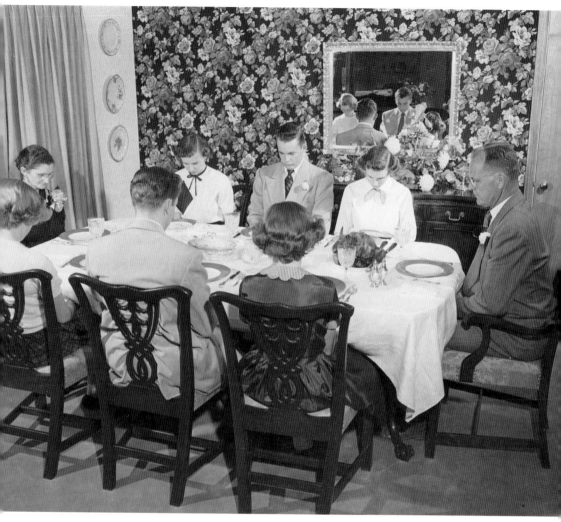

Walter Oscar Workman

Arlington residents who grew up in the 1950s fondly remember Workman's Drugs at Main and Center Streets. Walter "W.O." Workman also developed and built homes in the Park Row Addition and established a nursery. Workman participated in the organization of the Arlington Kiwanis Club. Under his presidency, the club sponsored the organization of the Key Club, a young men's service organization in high school, and the Circle K, a young men's collegiate service organization. He was also one of the founders of Rolling Hills Country Club. The group held its first meeting in Workman's backyard where they began planning a club with 18 holes of golf, a tennis court, and a pool. Pictured at Thanksgiving dinner are, from left to right, (first row, backs to camera) Gail, Walter Jr., and Judy; (second row) Zeta, Jannette, Don, Annette, and Walter Sr.

The Greenhouse Spa

The Greenhouse Spa opened in 1965 as a venture between Neiman-Marcus, Charles of the Ritz, and Great Southwest Corporation. With such a pedigree, luxury and elegance were a given. The *New York Times* in 1965 noted the spa's "glistening white courtyard," marble floors, fountains, and heated swimming pool. Notable guests included the Duchess of Windsor in 1968 (shown here), Princess Grace of Monaco, jewelry designer Paloma Picasso, and actress Brooke Shields. For a two-week stay in 1965, costing $1,100, women slept in canopied beds, exercised, ate low-calorie meals, took herbal baths, and indulged in facials, massages, and beauty treatments. The *Times* reported that women could stay only one week for $600, "but, according to the [Greenhouse] staff, this accomplishes only half as much as a two-week stay."

Gene Allen's Gifts

Gene Allen and his wife, Nancy, came to Arlington from Nebraska in 1959 to open a pharmacy with Gene's brother. "We felt like there was a lot of opportunity in the area," he said in a 1984 *Dallas Morning News* interview, "greater than where we came from." Expanding from the pharmacy, he opened Gene Allen's card and gift stores and a gourmet food and housewares store called The Wooden Spoon.

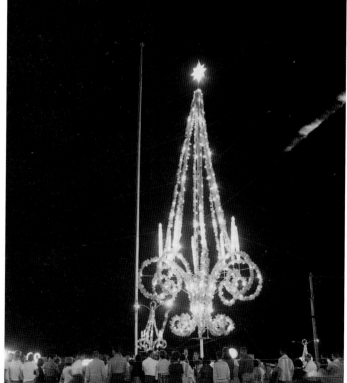

Park Plaza Shopping Center

Park Plaza, at the corner of Park Row Drive and New York Avenue, was once the greatest shopping and hangout in town. Opening in 1956, Park Plaza grew to host a movie theater, bowling alley, giant slide, The Fair department store (which became Titche's and then Joske's), and several restaurants. This photograph shows the Park Plaza Christmas tree in 1966. The center would also offer horse-drawn sleigh rides each Christmas.

Dan Dipert

Dan Dipert opened his first Arlington tour office in 1972. "Some senior citizens asked me to take them on a bus tour from Dallas to Austin," Dipert recalled in a 1989 *Houston Chronicle* article. "I did it for $16.50 and enjoyed it. Then they wanted to go to San Antonio. The next thing I knew, I was in the motor-coach tour business." Dipert has also taken a philanthropic role in the community. He is shown here (left) in 1976 with Roy Wood after he bought a wooden schoolhouse used in 1909. "It's part of our history and there's not much history left," Dipert told The *Dallas Morning News* in 1976. The building now resides in Knapp Heritage Park.

Robert C. Findlay and Interlochen

Any fan of Christmas lights knows about Arlington's Interlochen neighborhood. Built by developer Robert C. Findlay, Interlochen's lavishly lit homes draw about 40,000 guests during the holidays. The tradition started in the mid-1970s when Findlay started decorating his own home; then other Interlochen neighbors started decorating too. "It just took off like spontaneous combustion," he said in a 1992 *Fort Worth Star-Telegram* interview. Findlay is shown above next to an Interlochen canal in 1985. In the photograph below, Lamar High School students, from left to right, David Garrett, Amy Burwell, Jeremy Sweek, and Ty Howerton play Christmas songs to entertain visitors to Interlochen in 1990.

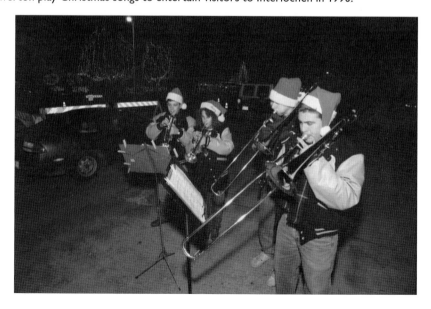

Angus Gilchrist Wynne Jr.

Though Angus G. Wynne Jr. never lived in Arlington, his influence has been felt in this city every day for more than 50 years. Wynne was raised in Dallas and graduated from the University of Texas. He worked the Texas oil fields until he entered the Navy and served with distinction in World War II. After his return to Dallas, Wynne began development of Wynnewood, a modern, high-quality community in Oak Cliff. The success he enjoyed and lessons he learned with Wynnewood were brought to bear in Arlington with the development of the Great Southwest Industrial District. Wynne's vision for a master-planned industrial district with high standards and quality controls was a revelation to other developers, who soon began to copy Wynne's ideas. To provide revenue for the district's infrastructure, Wynne developed a theme park modeled after Disneyland. Six Flags Over Texas, located north of the industrial district, took Arlington into a new economic direction and gave the city a national profile. Wynne is shown here at the park's opening day for the 1965 season. Six Flags Over Texas was such a success that Wynne later exported the theme park formula to Georgia and Missouri. Today, Six Flags Inc. owns or operates 19 parks worldwide and is the largest regional theme park company in the world. Wynne died in 1979, but the city has never forgotten the crucial role he played in its development. In 1997, Texas State Highway 360 in Arlington was officially renamed Angus G. Wynne Jr. Freeway. Discussing Arlington's explosive development in the 1950s and 1960s, former mayor Tom Vandergriff said in an August 25, 1997, *Dallas Morning News* interview that he was glad Texas SH 360 was being renamed. "So much credit has to belong to Mr. Wynne for his early efforts," Vandergriff said. "I am surely thrilled to know we are near giving him some recognition for all that he has done for our region."

CHAPTER FOUR

Temples of Knowledge

In the 1900s, rules for teachers included keeping the schoolroom neat and clean, scrubbing the floor at least once a week, and cleaning the blackboards. This was in addition to teaching multiple grades in underequipped classrooms. The problem was compounded in Arlington, which had an enrollment of 365 students and only six teachers. In 1895, the median age of Arlington's 1,000 citizens was a youthful 20 years old and, consequently, the town consisted primarily of young married couples with children to educate. As usual, the people's can-do attitude led to a solution. The alternative to ill-equipped and underfunded public schools was Arlington College. The school taught students from first grade through high school, with 10th grade as the highest grade. Public school principals William M. Trimble and Lee Morgan Hammond cofounded the school with the assistance of Edward Rankin. The private school consisted of a two-and-half-story wooden building with four classrooms and no plumbing. Arlington College and its succeeding institutions (Carlisle Military Academy and Arlington Training School) continued to offer private education to Arlington's youth until 1917. By that time, the town's public schools had better public support and funding. The success of public education was due to the supervision and guidance of principals such as John Kooken and James Martin and the dedication of talented teachers. Dora Nichols and others were legends known for taking a personal interest in their students and supporting extracurricular organizations that enriched the students' lives. The Council of Public Teachers Association supported the schools with scholarships and inoculation programs. Arlington's first post-secondary college was a junior vocational college built on the grounds of the former private school. Grubbs Vocational College experienced three name changes throughout the years, culminating in the University of Texas at Arlington. As with the public schools, the university benefitted from capable administrators like Edward E. Davis and Wendell Nedderman, and from outstanding faculty such as Duncan Robinson and E.C. Barksdale.

John A. Kooken

John A. Kooken came to Arlington in 1908 as the principal of the high school. School leaders wanted the well-built Kooken to help keep order in the rough-and-tumble environment. "The matter of discipline was a daily, if not hourly, problem, and the paddle and the strap were very much in evidence every day," Kooken wrote in his 1941 memoirs. He became superintendent for Arlington schools in 1913 and stayed on the job until 1938. Kooken Elementary, shown here in 1964, opened in 1939 and is the oldest building still being used by the Arlington Independent School District. It started as an elementary school but converted to a diagnostic and materials center in 1976. In 1988, it reopened as a preschool. Today, it serves special-needs and at-risk preschool students. John Kooken died in 1943.

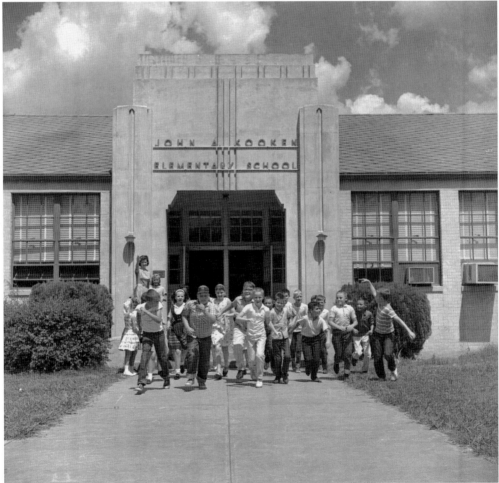

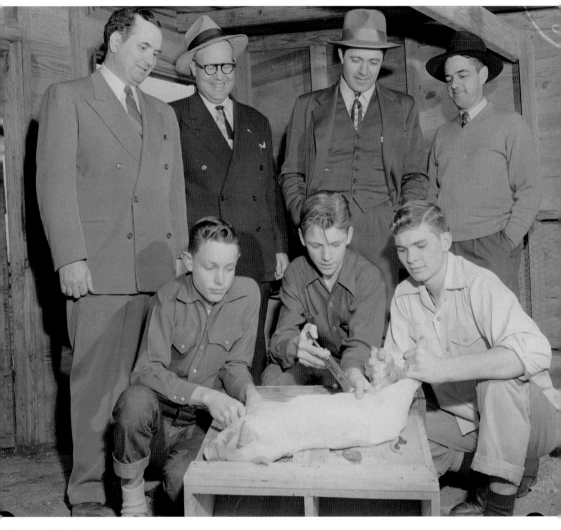

James Martin

James Martin and his wife, Eleanor Grace, arrived in Arlington in 1945 so that Martin could assume the job as principal of Arlington's only high school. He is shown here (left) in 1949 with, from left to right, (standing) Mike Ditto, Hayden Johnson, and Jerry Mebus, watching students Jackie Brown, Jim Strickland, and Neal Tucker vaccinate a pig. Next, Martin was appointed superintendent of Arlington schools. His tenure, from 1955 to 1976, was marked by explosive growth and integration. "He served at a time when there was a need for enormous expansion of our school system, and it's fortunate that we had somebody of his caliber," said Tom Vandergriff in a 1997 *Arlington Morning News* article. Upon his death in 1997, former students, teachers, and friends recalled Martin's warmth and generosity. Martin High School, named for him, opened in 1982.

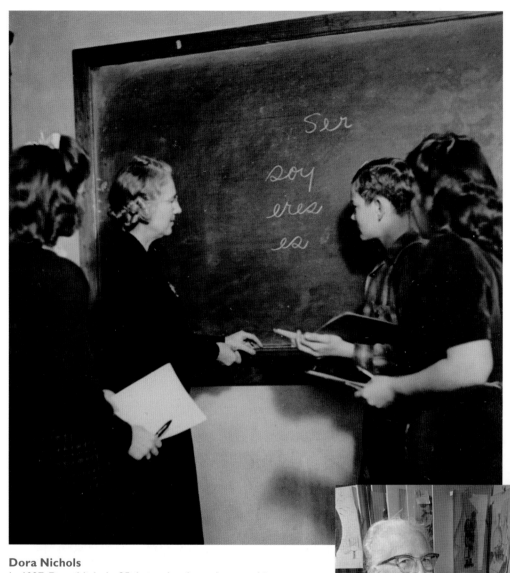

Dora Nichols

In 1927, Dora Nichols, 35, began her legendary teaching career. She taught Spanish and English at Arlington High School and was known for wearing fresh corsages in tiny, water-filled glass tubes. After retiring in 1958, Nichols stayed involved in education by taking an active interest in the junior high school named in her honor in 1960. Former Arlington superintendent James Martin said of her: "She was one of the great ladies, devoted to service to other people. She regarded her students as her boys and girls and felt like she had to be an example to everyone." Arlington City Council member Ken Groves recalled: "She was always very enthusiastic about the courses she taught and she took a personal interest in all of her students. She made it a point to know something about each of us."

Zeta Mae Workman

Zeta Workman was a charter member of the Council of PTAs, Friends of the Library, and Arlington Art Association. Workman was also a civic leader for the March of Dimes and was instrumental in obtaining the Cooper house for the city to use as a library. In 1958, the City Council and PTA honored her with a Zeta Workman Day and by planting trees at local schools. Workman and her husband, W.O., were active members of First Baptist Church, where Zeta enjoyed teaching Bible study classes. The city recognized the couple's volunteerism in 2001 with a 10-acre W.O. and Zeta Workman Park, which features a playground, hiking trails, and sports fields. (Courtesy of Jannette Workman.)

Bauder Fashion College

UT Arlington's "Nicest Neighbor," Bauder Fashion College and Finishing School came to Arlington in 1968. Located on Center Street, the college offered two-year degrees in fashion merchandising, fashion design, and interior design. Modeling, advertising, and "finishing training" were added later. Bauder had a reputation for having a good-looking student body, helped by the fact that the college's swimming pool was easily visible from the street. In the late 1970s and early 1980s, students came from around the world to attend the school. Shown in this 1985 photograph are, from left to right, Taybeh Soltani from Iran, Cynthia Pendley from Conroe, Texas, and Jaime Serna from McAllen, Texas. The college closed in 1995.

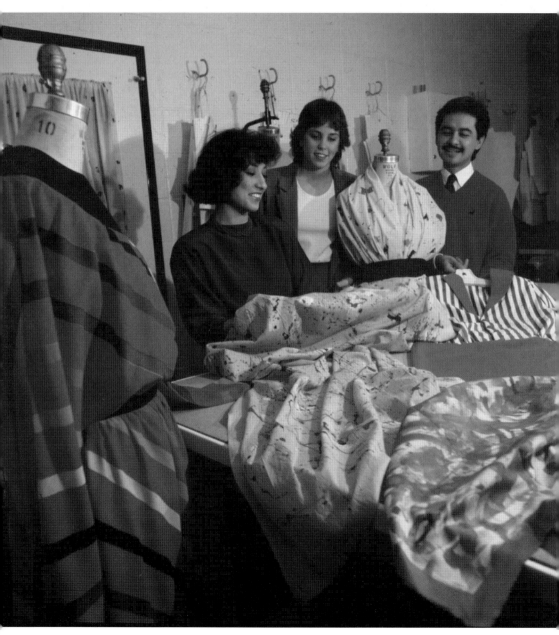

Edward E. Rankin

Local pioneer merchant Rankin was looking to the future when he promoted a better education program for the young community of Arlington in 1895. He spearheaded the drive to secure labor and materials and convinced two public educators, Lee M. Hammond and William M. Trimble, to found Arlington College. It is doubtful, however, that he could have anticipated that almost 75 years later, after eight name changes and decades of growth, what started as a school for primary and secondary students would become the University of Texas at Arlington. In addition to supporting the private school, Rankin was the first justice of the peace in the town and ran a grocery and hardware store on East Main Street.

William M. Trimble and Lee Morgan Hammond
In 1895, William M. Trimble (above) cofounded Arlington College with Lee Morgan Hammond (below) at the urging of Edward Emmett Rankin, who was not satisfied with the public schools in Arlington. It was not a college as defined today but rather served primary and secondary grades through 10th grade. Each man invested $500, and together they sold $100 scholarships to parents. The Ditto and Collins Land Company provided land for the school. Trimble remained at the school for three years and left to become a physician. Hammond remained until 1900 when the school began to have financial problems. Arlington College was the first of eight educational institutions that ultimately became the University of Texas at Arlington where Trimble Hall and Hammond Hall are reminders of the cofounders' contributions.

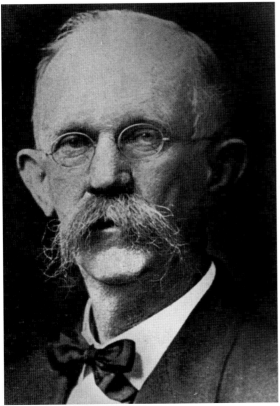

Col. James M. Carlisle
Carlisle, former Texas state superintendent of public instruction from 1889 to 1899, proposed to Arlington in June 1902 that he would relocate his private military academy from Hillsboro, Texas, to Arlington if the city would donate the property from the failed Arlington College and build a dormitory. The city agreed, and Carlisle Military Academy, a forerunner of the University of Texas at Arlington and noted for high academic and physical standards, opened that year. Pictured below is the two-story frame building with what is believed to be Carlisle and his wife, Julia. The building served as their residence, a dining facility, and a dormitory for 30 cadets. Despite being advertised as a school for the literary, military, and manual training for boys, girls were welcomed when enrollment declined. The military academy remained in operation until 1913.

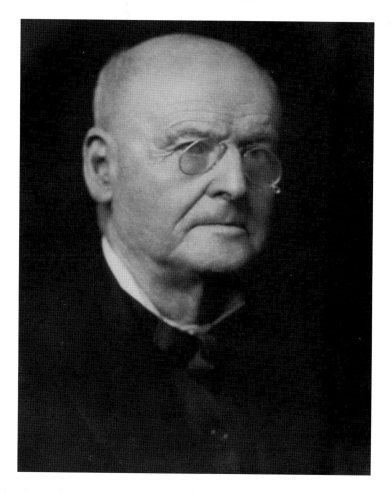

Vincent Woodbury Grubbs

Born in Kentucky in 1848, Vincent Woodbury Grubbs arrived in Kaufman, Texas, with his mother in 1855. The family was poor, and Grubbs's education had been neglected throughout his childhood. Nevertheless, at age 18, Grubbs decided it was time to settle down and pursue his education. After attaining a law degree, he started his law practice in 1874 and became a judge in Greenville, Texas, in 1884. A social reformer at heart, Grubbs was a determined prohibitionist and a vocal supporter of women's suffrage. In 1897, he became interested in industrial, or vocational, education. His theory was that current educational practice denigrated manual labor and thus left many young men and women ill-suited for life's realities. For 20 years, Grubbs worked tirelessly to convince legislators and the public of the benefits of vocational education. His efforts led to the creation in 1903 of the Girls' College of Industrial Arts in Denton, now Texas Woman's University. Success came again with the creation of Grubbs Vocational College in 1917 on the grounds of Arlington Military Academy. Grubbs College was a branch of the Agricultural and Mechanical College of Texas, now Texas A&M. As such, it focused on agricultural topics for men and the domestic arts for women. Arlington was delighted by the new college, but Grubbs himself was not pleased with the outcome, believing that Grubbs College should not be a branch of A&M. He refused to have anything more to do with his namesake college, and in 1918, moved his family to California, where he died in 1928. Grubbs College, whose mascot was the Grubbworm until 1921, grew rapidly despite World War I. In 1919, Grubbs students started publishing a monthly campus magazine called *The Shorthorn*, which is still in publication today. Grubbs College ended in 1923, when the school changed its name to North Texas Agricultural College.

Edward Everett Davis

When E.E. Davis became dean of North Texas Agricultural College in 1925, he began a 20-year building program. His aggressive recruitment of faculty and students helped NTAC become the largest junior college in the Southwest. At the presentation of a bust of Davis to the college in 1941, professor Duncan Robinson said, "Certain it is, in the gray days through which we have all passed since the coming of the Great Depression, we have been cheered by a characteristic joke or anecdote from the Dean. Laughter has been no stranger to him, and it would be ironic if he should be remembered too piously, for of all men, he is no weasel-souled pedagog sanctimoniously progressing into futility." Davis Street is named in his honor, and Davis himself planted the grove of pine trees at Davis and Park Row drives.

Carlisle Cravens

Carlisle Cravens graduated from Arlington High School and attended North Texas Agricultural College. He is shown here in his NTAC uniform. He got his law degree from the University of Texas and worked in Fort Worth. He led the effort to make Arlington State College into a four-year institution and served on the Arlington school board for 10 years. He was twice elected to the state board of education.

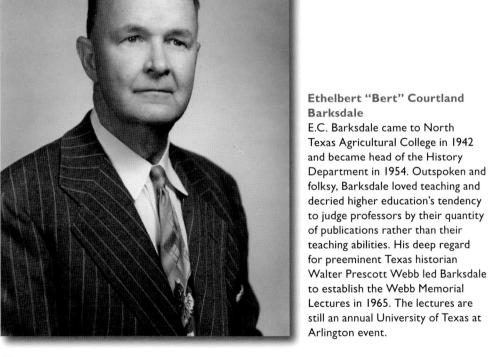

Ethelbert "Bert" Courtland Barksdale

E.C. Barksdale came to North Texas Agricultural College in 1942 and became head of the History Department in 1954. Outspoken and folksy, Barksdale loved teaching and decried higher education's tendency to judge professors by their quantity of publications rather than their teaching abilities. His deep regard for preeminent Texas historian Walter Prescott Webb led Barksdale to establish the Webb Memorial Lectures in 1965. The lectures are still an annual University of Texas at Arlington event.

Duncan Robinson

Robinson, then age 24, came to North Texas Agricultural College in 1928 to (in the words of E.C. Barksdale) "teach five sections of English, coach the debate team, organize a literary society, sponsor student publications, and serve as the college public relations, publicity, and public information official." Robinson, standing at right with James Martin (left) and Mike Ditto (center) in 1947, did all that and more. Perhaps Robinson's wife, Elsie Robinson, said it best when she told Barksdale: "He is not married to me. He is married to that damned college."

Robinson was a lively writer and gifted speaker, causing more than one person to compare him to Mark Twain. He loved recounting how he and former NTAC dean E.E. Davis would go to East Texas to recruit students. "We spent summers in the corn fields of East Texas, which had just struck oil and was prosperous, trying to persuade some gullible young people to attend our college." Every Christmas, Robinson would read Charles Dickens' *A Christmas Carol* to rapt audiences. "The old classroom in the building now called Ransom Hall echoed with the Spirits of Christmas Present and Past, with the voices of the Cratchits and Scrooge, and Tiny Tim God-blessing us every one," wrote Billi Rogers. "Twenty-odd freshmen students were spellbound by the sonorous voice, and probably those now middle-aged adults still associate Christmas and Dickens with Duncan Robinson." As he, and many of his generation, got older in the 1970s, Robinson started collecting oral histories from people who witnessed the growth of the university. His interviewees included Carlisle Military Academy student Ella Vincent, NTAC student Frank Yates, NTAC teacher Martha Hughes, and University of Texas at Arlington coach Burley Beardon. Above all, Robinson cherished his role as teacher. "The function of a university is to open the windows of the human mind, and the function of the teacher and the scholar is to help pry them open," Robinson said in 1968. "I think that above all a teacher should try to be a reasonably first rate human being." Robinson died in 1983.

Ernest H. Hereford

In 1948, Ernest H. Hereford was named the first president of North Texas Agricultural College, which became Arlington State College the following year. During his 10-year tenure, enrollment nearly quadrupled and several buildings were constructed, including the present-day student center that bears his name. The Rosebud Theater inside the center was named in honor of Hereford's love of roses. In his lifetime, he cultivated more than 19 varieties. Hereford died in office in 1958. In 1959, ASC unveiled a bronze bust of Hereford that now resides in the student center. Campus legend has it that rubbing Hereford's head before a test will bring good luck.

Arista and Howard Joyner

Arista and Howard Joyner's lasting gifts to Arlington are the Arlington Museum of Art and the commemoration of Arlington's history. The Joyners came to Arlington in 1937 so that Howard could organize the art department at North Texas Agricultural College. In 1952, the Joyners helped found the Arlington Art Association, which led to the opening of the art museum in 1989. Arista Joyner was a multitalented artist, teacher, and writer. In 1951, she began working for the *Arlington Journal* as the woman's editor and writing down stories from longtime residents. This piqued her interest in local Arlington history. She was selected to write about the history of Arlington for the 1976 bicentennial and later wrote a second book with René Harris. Though out of print, these books continue to be the starting place for research about Arlington.

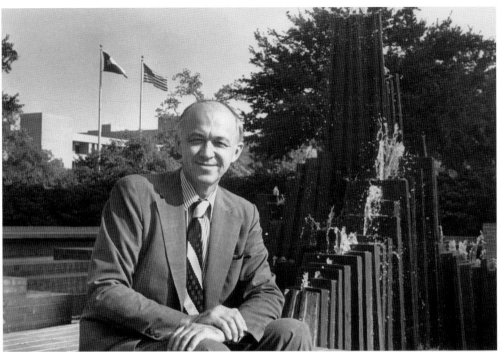

Wendell Nedderman

Wendell Nedderman was University of Texas at Arlington's president from 1972 to 1992—a period of significant growth and maturation for the university. During his tenure, UT Arlington added 64 degree programs and 24 buildings and went from 14,000 students to more than 25,000 students. "Somebody asked me once . . . what do I consider my greatest legacy?" Nedderman said in 2007 to *UTArlington Magazine.* "My greatest legacy is that I was an honorable man."

Maxwell Scarlett

In 1966, Fort Worth native Maxwell Scarlett became the first African American graduate of what is now the University of Texas at Arlington. He transferred to what was then Arlington State College in his senior year and graduated with a degree in biology. He later earned his medical degree from Howard University in Washington, DC. Doctor Scarlett remains an active and honored member of the UT Arlington community. (Courtesy University of Texas at Arlington.)

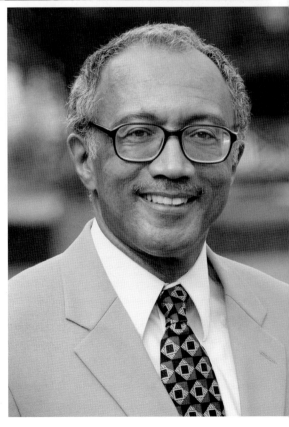

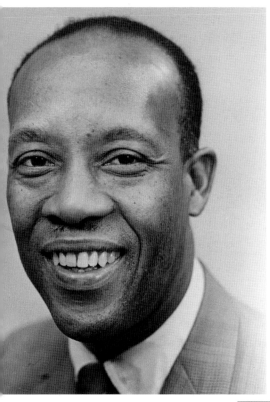

Reby Cary

In 1969, the University of Texas at Arlington hired Reby Cary as its first African American faculty member—a significant hire for a campus enduring racial tensions in that turbulent year. Cary served as assistant professor of history and associate dean of student life. He started the Minorities Cultural Center and promoted minority studies on campus. These early efforts in diversity education continue to bear fruit today. In retirement, Cary writes and publishes on historical topics.

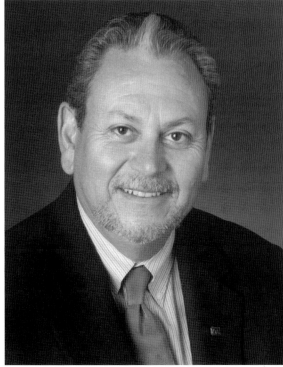

José Angel Gutiérrez

Gutiérrez is a lawyer, holds a PhD in government, is a player in Texas politics, and teaches political science at the University of Texas at Arlington. He is also a man who knows what it is like to work in the fields and suffer the injustices of racism. Because of this, José Angel Gutiérrez has been an outspoken proponent for Mexican American rights and participation in government for more than 40 years. (Courtesy University of Texas at Arlington.)

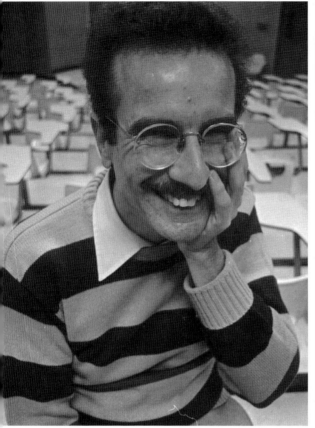 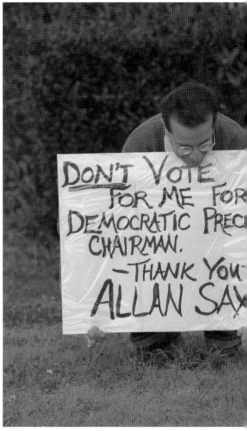

Allan Saxe

University of Texas at Arlington faculty member Allan Saxe—a noted philanthropist, political scientist, author, lecturer, and commentator—is energetic and quirky, perhaps best described as an "eccentric philanthropist" by the *Fort Worth Weekly*. He once impulsively donated his pickup to a charity after finding out that the organization's truck had broken down. Saxe usually gives with the condition that his name be displayed in a prominent place. Allan Saxe Field, Allan Saxe Park, Allan Saxe Dental Clinic, and Allan Saxe Parkway all bear witness to his support. Saxe became active in the community after an unsuccessful 1975 city council bid. In 1977, he ended up in a runoff for Democratic precinct chairman with one write-in vote. He made it very clear that he did not want the job by posting a sign in his front yard. He lost the race to a Republican.

CHAPTER FIVE

Everyday Heroes

What defines a hero? Is it bravery, tenacity, or selfless service to a cause? Is a hero one who achieves the extraordinary, or could a hero simply be someone who tirelessly and cheerfully goes about their daily work? One thing is certain: they come in all sizes, shapes, and colors, and Arlington has no shortage of them.

Civic and special-interest clubs have a long and heroic history of service to Arlington. In 1914, the Civic League championed city sanitation and clean streets. It also urged the city to provide resources for the residents' cultural well-being. The Commercial Club, formed in 1901, promoted business and pushed for civic improvements. The Masons and the Order of the Eastern Star were of great importance to early Arlington. When the cornerstone for the Eastern Star home was laid in 1924, more than 1,000 people attended the ceremony. Businesses, public schools, and the college all closed early so that people could celebrate the event. Today, groups like the Rotary Club and Kiwanis offer scholarships, charity work, and fellowship.

Some heroes braved great danger to save others. Nina, a German shepherd, rescued the Perkins family after a fire broke out in their Arlington home in 1959. When the fire started, Nina repeatedly tried and failed to wake the family. Finally, the dog dragged the baby, Becky Perkins, out of the burning home. Becky's screams awoke her parents and the whole family was saved. Carolyn Cunningham, only six years old in 1960, also saved her family from a fire. Her presence of mind during the catastrophe would have been commendable for someone of any age.

Heroes can be those who break barriers for others. The 1960s and 1970s brought great cultural shifts to Arlington. Women who had honed their skills in the PTA and Junior League turned their efforts to running for office and fronting large organizations. African Americans achieved positions and ranks not available to them under segregation.

Finally, heroes can be those who lend a hand when it is needed. For four years during the Cold War, the city of Arlington sent aid to the Bavarian town of Köenigshofen. Boxcar loads of supplies and gifts traveled from the Arlington depot, across the United States, the Atlantic Ocean, and Europe to help refugees who had fled East Germany. The effort was so appreciated that the German community and Arlington remain sister cities today.

However one defines a hero, examples can be seen in Arlington's past and present.

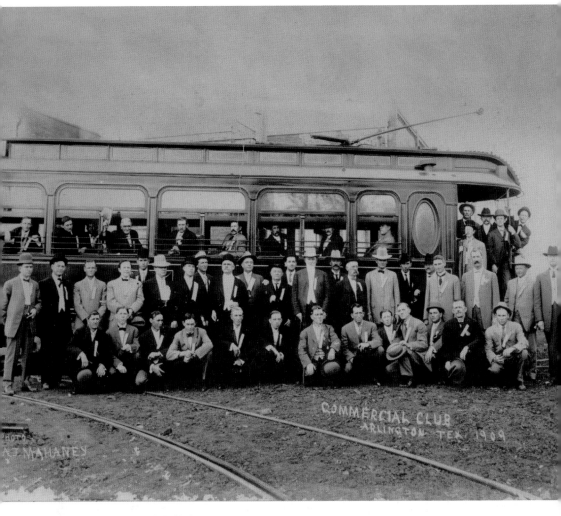

Arlington Commercial Club

In 1901, Arlington businessmen formed the Arlington Commercial Club, forerunner of the chamber of commerce, with officers Col. James I. Carter, president; James Ditto Jr., vice president; and Karl H. Word, secretary-treasurer. The 33 members were united to boost development of the city. As in similar small towns at the beginning of the 20th century, civic leaders enthusiastically promoted the virtues of their settlement in the hope of attracting more residents and (not by chance) more customers for their businesses. The members pose in 1909 in front of an interurban car.

Kiwanis Club of Arlington
Arlington's first Kiwanis Club, forerunner of all of the Arlington Kiwanis Clubs today, formed in 1952 with 18 members. Standing behind newly elected president Earl McDonald in a photograph taken at the first meeting are, from left to right, unidentified, secretary Clarence Myers, and president-elect Sam Hopper. True to their motto "We Build," the group contributes to playgrounds, supports reading programs, helps Scout troops, and adopts elementary schools. They meet at noon every Wednesday at First United Methodist Church.

Arlington Garden Club

Arlington's Garden Club, established in 1926, was part of the broader women's club movement of the late 19th and early 20th centuries. Middle-class women formed the clubs because modern household appliances gave them more leisure time to engage in intellectual pursuits and support social welfare goals. Arlington's Garden Club founders did not limit themselves to the improvement of their own gardens. Instead, they took an interest in civic improvement, created an award-winning municipal rose garden, and beautified Arlington's public parks. Shown from left to right in this 1970 photograph at the Texas Community Improvement Program award ceremony are Rex Givan, J.P. Plain, Tom Vandergriff, and Barbara Lane. The club received a $500 check to improve Randol Mill Park. The Arlington Garden Club continues to meet at the Fielder House Museum.

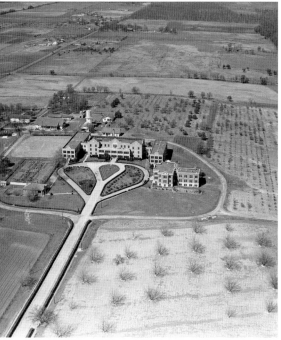

Eastern Star Home and Texas Masonic Retirement Center

When the Eastern Star Home opened in 1924, thousands of people came to celebrate. Initially, the home housed children and adults, but it eventually became a retirement home for women. The home, shown above in 1955, was a self-contained facility that included a beauty salon, chapel, exercise facilities, a library, and a post office. In 2001, the Eastern Star Home shut down and moved its remaining residents to the Texas Masonic Retirement Center, which started out as the Home for Aged Masons in 1911. Shown at left in 1921, both men and women could reside at the home, which was described in 1911 as spacious, grand, inviting, and fireproof. Amenities included washstands in each room with hot and cold water, electric lights, and steam heat. Today, the home serves about 150 residents.

Arlington Historical Society

For 125 years, members of the Arlington Historical Society devoted their efforts to preserve Arlington's historic past and educate people of all ages about the small frontier outpost that evolved into a vibrant city. Originally created in 1887 as the Cemetery Society with a mission to preserve local cemeteries, the organization now maintains the historic Fielder House, Knapp Heritage Park, and the Middleton Tate Johnson Family Cemetery. The Fielder House is part of the nostalgic past of the early 1900s, built by landowner and community leader James Park Fielder. The Texas Historic Landmark building features permanent exhibits such as a replica of Dr. Zack Bobo's office and is the official home of the Arlington Historical Society.

Vickie Bryant
Historian Bryant is an expert on the Top O' Hill Terrace casino, where drinking, gambling, and outrageous behavior took place in the 1930s. Set aside a few hours for a tour, or read her book, *Top O' Hill Terrace*, for a balanced account of the wicked events at what is now Arlington Baptist College. Bryant is holding the Bible of the college's founder, J. Frank Norris. (Courtesy George Moreno.)

René Harris
Local historian and author René Harris served as the director of the newly founded Fielder House Museum and Foundation in 1980. The house, among the old oaks at Fielder Road and Abram Street, contains exhibit halls and classrooms. In 1982, Harris collaborated with Arista Joyner in writing *Arlington, A Pictorial History*, which features historic photographs and Joyner's sketches of historic sites.

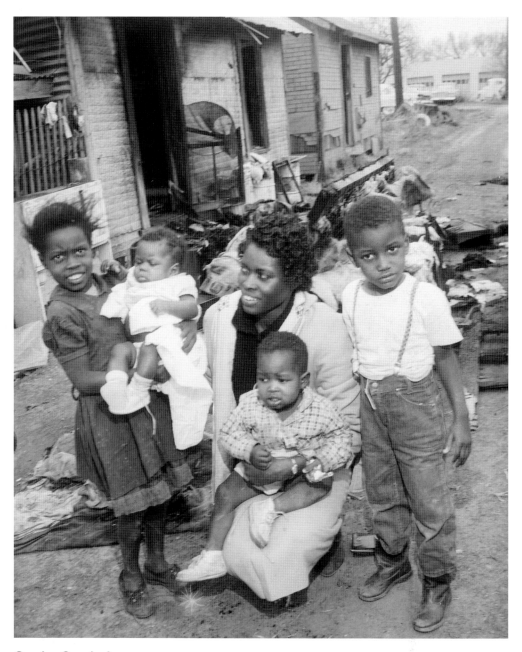

Carolyn Cunningham

When fire broke out in the Cunninghams' small home in February 1960, the quick-thinking six-year-old Carolyn snatched her baby sister, Paula Kay, from a blazing blanket. On her way to the front door, she clasped the hand of her brother, year-old Michael Reed, while calling to Patrick Owen, her other brother. Thanks to Carolyn, the family made it out safely. The building was completely ablaze before neighbors called the fire department. The family was only able to save the clothes they were wearing and the washing on the line. The extent of the tragedy is evident in this picture of Carolyn holding her baby sister while posing with her mother and two brothers in front of the ruined home. Local church and civics clubs, upon learning of the disaster, united to gather clothing and meet the immediate needs of the family.

Drs. Joseph Milton and Don Farrell
Since they were children, brothers Joseph Milton "J.M." (right) and Don Farrell knew they wanted to be veterinarians together. After World War II, J.M. moved to Arlington and started a veterinary practice out of his home on Pecan Street. When Don earned his degree from Texas A&M, the two opened Farrell Animal Hospital in 1948. In 1968, Don left the practice to start 303 Animal Clinic in Grand Prairie. A few years later, J.M. sold the Division Street building to Dr. Herbert C. Schoonover and built Farrell Animal Hospital on Pioneer Parkway. J.M. also became involved in the Arlington school board, being first elected in 1965. In 1989, AISD named J.M. Farrell Elementary in his honor. (Courtesy Farrell Animal Hospital.)

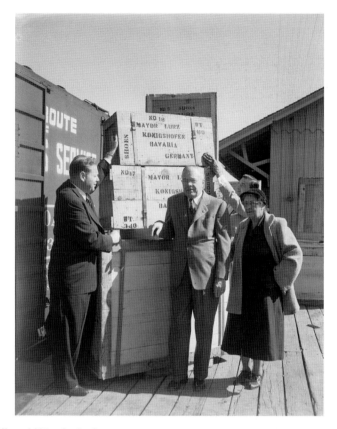

Grethal Howell and Köenigshofen

In the summer of 1951, soon after the start of the Cold War, Kurt Zühlke, city manager for the Bavarian town of Köenigshofen, visited Arlington at the behest of his traveling companion, Irene von Falkenried. Falkenried had a pen pal, Theda Howell, whom she wanted to visit. Zühlke and Falkenreid stayed two weeks at the Howells' home and told Theda's parents, John and Grethal (on the right), about the stressful conditions of Köenigshofen. Thousands of refugees were fleeing communist East Germany and coming to Köenigshofen, three miles west of the border between East and West Germany. As it was a town of only 7,000 people who were still recovering from World War II, Köenigshofen was ill equipped to handle the influx. Grethal Howell immediately began sharing Zühlke's story with the people of Arlington through the chamber of commerce, business and service clubs, and Mayor Tom Vandergriff. Soon, the city decided to "adopt" Köenigshofen and send aid. In February 1952, the first shipment of food and clothing for refugees was loaded in a boxcar to begin its journey from Arlington to Köenigshofen. Not only was this a gesture of friendship and humanity, but it was also Arlington's way of striking a blow for democracy in the Cold War. Posters soliciting for the drive said: "Conquer Communism. Let freedom ring. Help refugees from behind the Iron Curtain." Grethal Howell headed up three more drives in the following years, and in return, the German people sent letters, photographs, and handmade gifts to Arlington expressing their deep thanks. After the refugee crisis passed in the late 1950s, a more equal friendship developed. Arlington continued to cultivate ties to Köenigshofen as the relationship changed from an adopted city to a sister city. Groups from each town have visited the other, and marks of this 60-year friendship can be seen in both places. Bad Königshofen, as the town is now called, has a city park called "Arlington-Park" and a fountain partially financed by an Arlington gift. In Arlington, Stovall Park features the Bad Königshofen Recreation Area and Bad Königshofen Family Aquatic Center. Grethal Howell's determination to send help overseas cemented a lasting bond between the two cities and led to our sister-city motto of "Friendship—solid as a rock."

Penny Carlisle and Margaret Kantz
A women's T-shirt for sale in 2012 at the University of Texas at Arlington reads, "I am the engineer my mother always wanted me to marry." Women in the sciences today have come a long way from the 1960s. Out of 2,000 engineering students in 1966, 15 were women. Margaret Kantz and Penny Carlisle were the first two women to graduate with engineering degrees in the college's history. Carlisle graduated in January 1967 when the college was still called Arlington State. Kantz graduated in May that year under the UT Arlington name. While students, Carlisle and Kantz helped start the first chapter of the Society of Women Engineers in Texas.

Dale Pointer

Dale Pointer had no idea what to expect on his first day of classes at Arlington High School in 1965. "I saw what happened to James Meredith at the University of Mississippi in 1962," Pointer told the *Dallas Morning News* in 1999. Fortunately, integration problems at Arlington High were few. "After that first day, I felt right at home. There were no ugly incidents." Pointer, son of Ruffin Pointer, played football

for Arlington High. He is shown here in 1965 in the top row, fourth from left. He was the only African American member of the team. He and Sonja Gilmore were the first African Americans to graduate from Arlington High in 1967.

Etta Hulme

Arlington resident Etta Hulme provoked laughter and ire from the readers of the *Fort Worth Star-Telegram* with her award-winning editorial cartoons. She started with the *Star-Telegram* in 1972 and retired in 2001, though she continued to draw on a contract basis for the paper. "A cartoonist ought to provoke," Hulme said in a 1993 *Star-Telegram* interview. "If I go too long without one of my cartoons gettin' me in the soup, I start to worry." In 1981, Hulme was the first woman to win the National Cartoonists Society award for the editorial division. She won again in 1998. Prior to being an editorial cartoonist, Hulme worked for Walt Disney Studios and later illustrated the *Red Rabbit* comic book series.

Daniel Miller

"How do you represent a state so rich in history and culture on one coin?" This was the question that Arlington graphics designer Daniel Miller asked himself when he entered the contest to design the Texas quarter for the US Mint. Miller's winning design, chosen from among 2,800 others, started circulating in 2004.

Lico Reyes

A self-described Renaissance man, Lico Reyes graduated from the University of Texas at Arlington with a degree in math, started a disc jockey and entertainment business in 1970, served in the Texas State Guard, was named LULAC's National Civil Rights Man of the Year in 2002, and has run for Arlington city office at least a dozen times, never winning. Reyes devotes much of his time to defending civil rights within the Metroplex and state. (Courtesy Lico Reyes.)

Theron Bowman

Fort Worth native Theron Bowman joined the Arlington police force in 1983 and broke barriers by being Arlington's first African American sergeant in 1988. He rose through the department's ranks, finally becoming the city's first African American chief of police in 1999. Bowman was conscious of his role in diversifying the force. He dedicated his doctoral dissertation to "others like [him] with the courage to defy the odds." (Courtesy Arlington Police Department.)

Lauretta Hill

In 1999, Lauretta Hill became the first African American woman to become a sergeant in the Arlington Police Department, but even then she had bigger goals. "Hopefully, one day," she said in a 1999 *Fort Worth Star-Telegram* interview, "I'll be a deputy chief. That's my goal." Hill's goal became reality in 2008. "Hopefully my achievements will encourage others to follow in my footsteps," Hill said in a 2008 *Star-Telegram* interview. (Courtesy Arlington Police Department.)

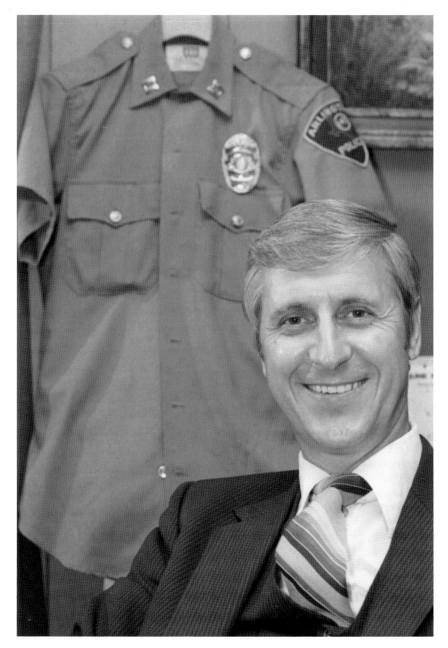

Rev. Harold Elliott

Harold Elliott's warmth and compassion are immediately obvious, even over the telephone. It is a quality that served him well as the Arlington Police Department's chaplain for 30 years. Pictured here in 1981, Elliott comforted the families of victims as well as the officers working horrific cases. "Almost every time that I get called out in the middle of the night, I ask myself why I do it," Elliott said in a 1997 *Arlington Morning News* interview. "I no more than see the people there and I know why I do it. People are hurting." But Elliott's job also brought joy. He has performed marriages and hosted an annual New Year's Day breakfast for police at his home. He started collecting Arlington police memorabilia in 1982. Today, visitors can view the department's history at the Harold K. Elliott Police Museum.

Margaret Rose May

"This farm will provide something for every generation," Martha Gibbons told her granddaughter Berta Brown. Berta Rose Brown and her sister Margaret Rose May, descendants of pioneers James Preston Rose and James M. Gibbons, deeded 200 acres of the original Gibbons property to the city with the stipulation that it be used for a park. The land along the Trinity River is now River Legacy Park, an educational, recreational, and natural resource. The park benefits this and future generations. Celebrating the opening and holding a map of the new park are, from left to right, Melissa Rose Martin, Margaret Rose May, and Martha May Martin.

CHAPTER SIX

Gone, But Not Forgotten

The story of Arlington is one of growth and expansion. People flooded into Arlington after 1950, businesses grew, and newer and bigger buildings were erected. Arlington's development has benefitted the entire north Texas region. But it is also a story of loss. Landmarks were paved over and buildings razed to make room for parking lots. Main Street disappeared and so did the thriving downtown life. But once gone, places like Arlington's landmark mineral well, favorite hangout Terry's Drugstore, and downtown's Rockyfeller Hamburgers were not forgotten.

People, too, have gone from Arlington. There were the old-timers who came in the late 1800s and early 1900s and who lived during the days of Arlington's dirt streets and wooden schoolhouse. Others were part of the Arlington boom after World War II and saw the town grow from 4,000 people in 1940 to 35,000 in 1955. These men and women—among them doctors, teachers, farmers, and law officers—are still remembered for their kindness and service to the community.

Some people left this Earth before their time. Their passing left Arlington sick with grief and determined to pay tribute to their memory. Lemuel Compton and George Conley died in service during World War I, while Neel Kearby and Delmar Pachl died during World War II. The Garden of Angels, a memorial to slain children, was started after Arlington resident Amy Robinson was killed in 1998. Through the garden, families have found peace and support after the loss of a loved one.

Though Arlington mourns the loss of places and people, residents pay tribute to them and are still inspired by them. The names of those gone may be honored on buildings, parks, memorials, and even laws, or they may simply be remembered as quintessentially Arlington—friendly, helpful, and full of life.

Will Leatherman

For the farmers around Arlington before World War II, postal carrier Will Leatherman was one of the most important people in their lives—he connected them to the outside world before there was rural electricity or phone service. Besides just delivering mail, Leatherman shared news of neighbors and often helped farmers with quick tasks like fixing a clothesline or completing errands. Leatherman was born in Alabama in 1889 and moved to Texas as a child. Like many rural men of his generation, his schooling stopped after the seventh grade. He joined the US Post Office in 1907 at age 17. At the time, rural mail delivery was still a new concept, having only started in Arlington six years earlier. Previously, farmers had to come into town to pick up their mail. In those earliest days of rural mail delivery, the Post Office expected carriers to provide and maintain their own horses and wagons. During the teens, motorcycle manufacturers like Indian and Harley-Davidson targeted their advertising to rural mail carriers and touted the benefits of motorized vehicles for rapid mail delivery. Here, Leatherman rides a Wagner motorcycle in 1914. Despite the motorcycle's benefits, Leatherman still had to hitch up his horse and wagon to deliver the mail when icy or muddy rural road conditions made motorized transportation impossible. By the 1920s, Leatherman and other rural carriers were routinely using cars and trucks to deliver the mail. In response to the improved transportation, the Post Office combined rural mail routes so that fewer carriers traveled more miles. In 1939, Leatherman traveled a nearly 40-mile route. His territory included parts of Grand Prairie, Hurst, Euless, and Bedford. Leatherman married Arlington native Susie Appleton in 1916. During his time off, they would ride Arlington's interurban to go shopping in Dallas or to nearby Lake Erie for fun. They also enjoyed going to the horse races at Arlington Downs during the 1930s. Leatherman retired from the Post Office in 1942 because of poor health. He died in 1947. In his obituary, the *Arlington Journal* said of Leatherman, "Plain spoken, but sincere, he held the respect of all who knew him. Many people feel that in his going, they have lost a trustworthy friend."

Andrew J. Mahanay

As a professional photographer, A.J. Mahanay created Arlington's pictorial past one shutter click at a time. He captured on film the old mineral well with its lion's head fountains that once graced the middle of Center and Main Streets and took photographs of Arlington homes long-since demolished. He snapped the image of the first airplane that landed in a dusty field as well as the first interurban to travel down Abram Street. Perhaps his greatest gift to posterity was recording the daily lives of Arlington's residents as they shopped, went on picnics, and celebrated family reunions. Mahanay, 85 years old in this photograph, first moved from Missouri to Johnson Station and worked on the family farm until he was in his 20s. After studying art at Baylor University, he returned to Arlington and studied photography under D.H. Schwartz, one of Fort Worth's early photographers. He opened his first gallery in central Arlington, where he had to sensitize his own plates and print pictures using sunlight. Mahanay never married; he lived most of his life with his mother, and after she died, with family members. In his later years, he recalled that the pleasure in his life was to "see the changes that have been brought about and the modern conveniences which have been established."

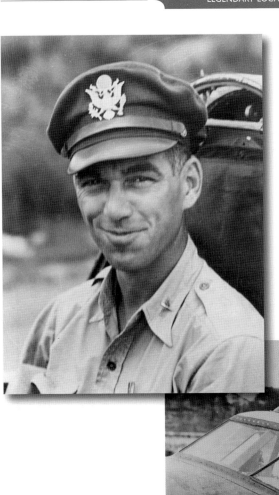

Col. Neel E. Kearby

A legendary fighter pilot, Kearby led the 348th Fighter Group in the Pacific Theater during World War II. Born in Wichita Falls, Texas, he spent his formative years in Arlington where he graduated from Arlington High School in 1928. He then attended North Texas Agricultural College, now the University of Texas at Arlington, before graduating from the University of Texas at Austin and joining the Army Air Corps in 1937. Kearby was awarded the Medal of Honor for destroying six enemy aircraft during a single mission in 1943. Flying a P-47 Thunderbolt, he was credited with 22 aerial victories before he was killed in action near New Guinea in 1944. The tragic news of his last flight was reported throughout the nation. (Courtesy of the National Museum of the US Air Force.)

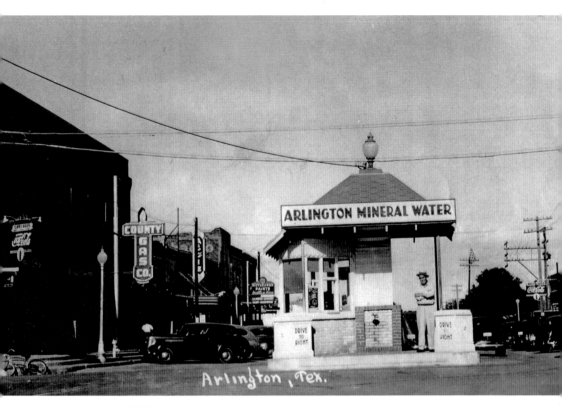

Arlington, Tex.

Arlington's Mineral Well

The citizens of Arlington needed water, so they did what any small 19th-century community would do: they dug an artesian well at Main and Center Streets. They started the process in late 1892, and the local media followed their progress. Finally, on December 8, 1893, the *Dallas Morning News* reported that, "their twelve months' labor was rewarded by a flow of about 200-300 gallons per hour." What the paper did not report was the water's terrible flavor—the result of its heavy mineral content. "The water was terrible," said Barbara Kight in a 1999 *Dallas Morning News* article. "It tasted like rotten eggs." But in the days of patent medicine, castor oil, and cure-alls, logic dictated that something that tasted that bad must be good for you. Arlington tried, for a while, to be a health resort along the lines of Mineral Wells. In 1909, the city granted a franchise to Dr. J.D. Collins for a sanitarium. Later, Gilbert Luke and his family sold crystals made from the water for use in medicines. People drove from miles around just to stop at the well and fill a jug or two to take home. No matter what commercial use the water was put to, the well itself was a community landmark and gathering place. When residents gathered in support of prohibition, they had their photograph taken around the well. Former mayor Tom Vandergriff recalled in 1976, "When you had a pep rally at school, you marched and had it around the well." Freshmen at North Texas Agricultural College were "initiated" by duck waddling from the campus to the well for a drink. And, most important, friends met friends by the well every day. "Any time something happened downtown," said Tom Cravens in the 1999 *Morning News* article, "it happened around the well." The city capped the well in 1951 because it was considered a traffic hazard.

Attempts to bring back the well, shown here in 1939, have never borne fruit. Today, a memorial for the fountain stands at the Arlington Public Library, and the lion's head monuments at Center and Division Streets recall Arlington's lost landmark.

Kathleen Fleming, Claudia Jean Reeves, and Marilou Goldner
The legend of Screaming Bridge is one of those local ghost stories that teenagers tell to thrill and scare their friends: teenage girls driving late at night do not notice that the bridge is out and plunge to their deaths. Now the site is haunted, and you can hear the girls' ghostly screams.

The true story, however, is far more tragic than the legend. In late January 1961, four Arlington males—three 18, one 17—burned down a bridge on the Arlington-Bedford road as a prank. Officials put up sawhorse barriers and smudge pots as a warning, but those disappeared with other vandals. These pranks would soon have devastating consequences. On the night of February 4, 1961, six girls from Arlington High School—Jo Ann Anderson, 16; Kathleen Fleming, 16; Marilou Goldner, 16; Dorothy Ibsen, 16; Donna Post, 16; and Claudia Reeves, 17—were on their way home from the movies. The surrounding darkness and slope of the road made it nearly impossible to see that the bridge was out, especially if one was moving with speed. Goldner shot the car 35 feet across the chasm and into the opposite wall of the dry creek bed. She and Reeves died at the scene. Fleming died the next day. The other three girls had devastating injuries but survived. The boys who had burned the bridge quickly came forward to confess. A grand jury declined to indict the boys, saying it was the unknown person who removed the barrier who should be prosecuted. That person was never found. The accident scene is shown in this 1980 photograph. The tragedy would forever haunt the friends and family of the deceased.

Marshall Morton

People called him "Little Marshall" and "The Marshall of Arlington." Standing only 4 feet 10 inches in cowboy boots, Marshall Pryor Morton was nevertheless a giant in terms of the loving impression he left on the residents of Arlington. He was easily recognizable, as he was habitually dressed in jeans, a Western shirt, cowboy boots, and a cowboy hat. He usually accessorized with a pair of nickel-plated cap pistols and a tin sheriff's star. Born with intellectual and physical disabilities in 1921, Morton grew up in Arlington and was a fixture on the Arlington State College grounds and downtown streets. "Marshall helps dozens of students in some little way every day," wrote ASC student Velma Prince in 1950. He opened doors for students burdened with books, escorted ladies across the streets, kept stray dogs and cats off the campus, and even picked up trash and kept the night watchmen company on their rounds. Downtown, Morton greeted visitors getting off at the bus station and used a whistle to direct traffic around the mineral well at Main and Center Streets. When Morton died in May 1961, the *Arlington Journal* published an editorial titled "Arlington Loses a Friend," noting that, "the lives of all who knew [Morton] were enriched a little because of his cheery smile, the wave of a friendly hand or the military salute which was his trademark."

Dr. Zack Bobo

A certain amount of pride comes through when an Arlington resident mentions being a "Bobo baby." In his 1931–1987 career, Dr. Zack Bobo Jr. estimates he delivered more than 4,000 babies in Arlington. Bobo delivered some babies on kitchen tables. "He also attended several women whose husbands stood by with lethal weapons for use should his treatment be unsuccessful," wrote Duncan Robinson in his introduction to Bobo's 1977 book, *Ramblings of a Country Doctor*. Bobo, shown here in 1947, was born in Wise County, Texas, in 1897 and grew up in Rhome, Texas, as one of 12 children. He earned his medical degree from Baylor Medical College in 1922 and came to Arlington in 1931. In 1936, he opened Arlington's first private hospital, which operated for 12 years. Bobo was known for his generosity. He donated $1.45 million to Baylor University, and a scholarship there still bears his name. For his patients, Bobo made allowances based on their ability to pay. In a 1983 *Dallas Morning News* article, Bobo said that during the Great Depression, he "never did charge the farmers south of Arkansas Lane [in Arlington] anything because they didn't have anything." Instead, he might be paid with vegetables or live chickens. He once received a five-gallon can of rancid hog lard. Bobo never retired. "If you quit your work or practice, you die," he said. Up until his death in 1987 from a fishing accident, Bobo saw patients in his Center Street office. That office is now recreated at the historic Fielder House in Arlington as a permanent exhibit.

Arthur Berry "Ott" Cribbs

Ott Cribbs, an Arlington native, joined the town's police force around 1926 and became chief in 1934. In the early days of his service, when someone phoned in an emergency to the switchboard, the operator would turn on a red light atop the building. When Cribbs spotted the signal, he would check into the office. During his tenure, Cribbs oversaw several firsts. In 1938, Arlington got the Drunkometer, the state's first mobile breath analyzer. In 1957, Cribbs started one of the first Junior Police programs in the country. In 1970, Arlington was the first city in the nation to use ORBIS, an electronic speed monitoring system. Cribbs retired in 1971. The Ott Cribbs Public Safety Center is named in his honor.

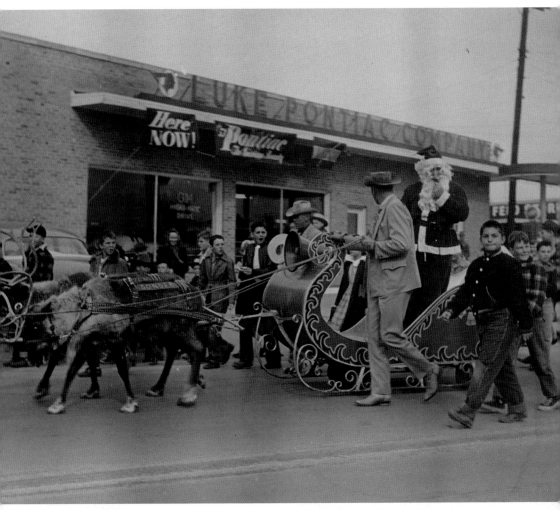

Howard "Gumpy" Moore

Former mayor Tom Vandergriff described Howard "Gumpy" Moore as the best Santa Claus he had ever seen. Arlington children waited eagerly for his Christmas visit on a sled on wheels pulled by reindeer. Moore, in business with his family at Moore Funeral Home, was active in civic affairs. Notably, he participated in the 1950s effort to get the people of Arlington to pay for a hospital. Vandergriff and other civic leaders wanted to prove that it was faster to push a wheelbarrow from downtown Arlington to the site of the proposed city hospital than to take an ambulance 20 miles to Fort Worth. James Hyden pushed the wheelbarrow while Moore drove one of the funeral home's ambulances. Hyden won the race, thus gaining support for the hospital, which opened in 1958. Howard Moore Park is his namesake.

Ella Virginia Day Vincent

Ella Virginia Day Vincent (front row, second from left in dark dress) was born in Arlington on December 31, 1893. Blessed with a vivid memory of her 91 years in Arlington, Day recalled never walking on the south side of Main Street where the saloons were located until after a visit by temperance activist Carrie Nation, who led a gathering of women and children shouting "Down with saloons!" in the early 1900s. Ella Day graduated from Carlisle Military Academy and spent her first working years as an elementary school teacher at South Side, Arlington's first brick school. Pay for teachers was poor, so when she was offered a banking job in 1919 that paid more in a week than she made in a month of teaching, Day took it. At First State Bank of Arlington, Day became the first female bank employee in Arlington. One day in the early 1930s, Day recalled, the bank president told her to go home; the bank had received word that Clyde Barrow and Bonnie Parker were on their way to Arlington to rob a bank. As she left the building, Day saw men with machine guns, watching for trouble, through the windows of another bank across the street. Apparently, Barrow received word that the town was prepared, and no robbery occurred. Day married newspaperman Upshur Vincent in 1932. The couple had no children. Day resigned from banking in 1937 to keep house but returned to it in 1943 and stayed until retiring in 1969. Other activities included membership in the Garden Club and the Arlington Business and Professional Women's Club, and singing at First Presbyterian Church. Day died in her beloved city in 1985.

Bill Bardin and the Witness Tree

Arlington's Witness Tree was more than just a relic of 19th-century surveys—it was literally a witness to history. When Caddo Indians farmed the land in the 1700s, the Witness Tree was there. While Middleton Tate Johnson settled his family at Marrow Bone Springs in 1848, the post oak tree continued to grow. When the Bardin family bought the land at what is now South Cooper Street and Bardin Road, the tree became theirs. Throughout the 1900s, the Witness Tree silently watched as Arlington grew from a small farming community to the third-largest city in north Texas. By the time this photograph was taken in 1986, the tree had grown six stories tall and was more than three feet in diameter. Bill Bardin, shown with the Witness Tree, loved the tree and knew his father had, too, so when he sold the family farm in 1986, Bardin stipulated that the new owner had to keep the Witness Tree alive for seven years or pay him $50,000 to be used for charity. "I got kind of tired of seeing nice trees bulldozed and I thought that would be a way to slow them down," Bardin said in a 1991 Fort Worth Star-Telegram interview. When Kmart started to build on the land, the company decided the tree had to be moved 450 feet. Experts disagreed about the tree's chance for survival, but the move started in December 1991. It was a massive and careful operation, costing Kmart about $200,000. Bardin supervised the entire process. As winter turned to spring, the community waited to see if the tree had survived. After the spring of 1992 brought a brutal hailstorm and summer threw its usual intense heat, the tree's reserves were gone; in June 1993, the Witness Tree was cut down and its wood fashioned into souvenir items. Yet though the mighty oak fell, it managed to sow seeds for the future of other trees by serving as a tangible rallying point for those who wanted to protect mature trees and preserve what history remained in Arlington. The result was that the city passed a tree preservation ordinance in 1993 for commercial development and extended it in 2005 to residential development. The stump of the tree was moved to a small park at West Bardin Road and Mansfield Road, where it remains, not as a witness but as a testament for Arlington.

Amber Hagerman

From an unspeakable horror grew a network of hope for missing children across the country. In 1996, nine-year-old Amber Hagerman was riding her bike in Arlington when she was abducted by a man in a truck. Four days later, her body was found. The case was never solved. In the aftermath of the tragedy, local police and radio stations came up with a system designed to get information about abductions out to the public as quickly as possible. Named the Amber Alert system in Hagerman's honor, the system grew to be used by all 50 states and several countries. In this 2003 photograph, Pres. George W. Bush signs the Protect Act, which formalized the Amber Alert system across the country. Amber's mother, Donna Whitson, can be seen with her arm around her son at left.

James William Dunlop

Not only did J.W. Dunlop save Arlington residents from fires and cats from tall trees, but he also saved much of Arlington's history from being destroyed. Dunlop, shown here in 1978, came to Arlington in 1939 and joined the volunteer fire department. In 1953, he became the department's third paid employee. He served as fire marshal from 1955 to 1978 and then as assistant fire chief until 1982. Outside of the department, Dunlop's passion was for Arlington history. He started collecting and copying historic photographs of Arlington until he had amassed a collection of more than 1,000 images. "I like to think of myself as a history hunter through photographs," Dunlop said to fellow Arlington historian O.K. Carter in a 2003 *Fort Worth Star-Telegram* interview. The J.W. Dunlop Sports Center is named in his honor.

James "Red" Wright

James "Red" Wright was born in 1888 and lived most of his life in Arlington. He served as Arlington's sheriff in 1912 and won a heated race for Tarrant County sheriff in 1928. In 1933, President Roosevelt appointed him US marshal for the northern district of Texas, a post he held until 1954. In the course of his career, he was involved with cases relating to Bonnie and Clyde, "Machine Gun" Kelley, and Jimmy Lucas. Wright is shown here in 1955 on his 165-acre farm north of Arlington. An avid collector of memorabilia, Wright is holding a blunderbuss; reportedly, he has one of Pancho Villa's saddles displayed on a tree limb.

Ruffin Pointer

Ruffin Pointer stood on his porch and looked out over the parking lots at Sanford and Taylor Streets. "That whole area wasn't nothing but pasture—cows and such," he said in a 1991 *Fort Worth Star-Telegram* interview. Pointer remembers those days. He remembers picking cotton and shining white men's shoes at the barbershop. Pointer, shown here in 1991, came to Arlington with his parents in 1925. They moved to a section of north Arlington called The Hill, where other African American families lived. When Pointer married, he and his wife, Vera, raised their family on The Hill. "Except for some fools here and there, there was no overt racism," he told the *Star-Telegram*. To the *Dallas Morning News* in 1999 he added, "Things are a lot better now then they were back when I was growing up."

Kalpana Chawla
Born in Karnal, India, Kalpana Chawla came to the University of Texas at Arlington and earned her master's degree in aerospace engineering in 1984. She joined NASA in 1994 and flew on the space shuttle Columbia in 1997— the first Indian woman to go into space. In 2003, she again flew on Columbia on a mission that ended in a terrible tragedy when the shuttle broke up over north Texas during reentry. A UT Arlington scholarship and residence hall are named in her honor. (Courtesy of National Aeronautics and Space Administration.)

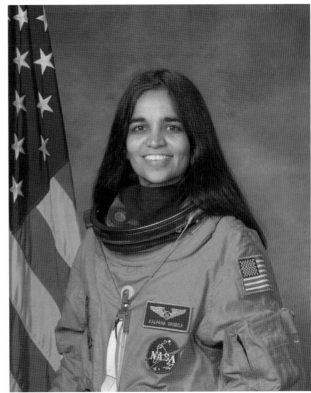

Martha Elliott Willbanks
When Martha Willbanks became Arlington's first female police officer in 1972, some officers did not think the petite 23-year-old would make it. Willbanks proved them wrong, staying with the department for 28 years and rising to the rank of lieutenant. Her tenacity, good humor, and love of police work helped her navigate those challenging early years and made her an inspiration and mentor for the female officers who came after her.

Jim Hayes

In the early 1970s, people in wheelchairs had a choice of majors at the University of Texas at Arlington. Their choice was history or accounting, because those classes were in the only wheelchair-accessible buildings on campus. Jim Hayes, left paralyzed after a diving accident on his 18th birthday, chose to study history in 1971, but he wound up making history instead. While a student, Hayes challenged university administration to get around campus in a wheelchair. Wayne Duke, vice president of student affairs, accepted the challenge. "There was not one building that he could independently get into, not one bathroom, one telephone, one water fountain," Hayes later recalled in a *Fort Worth Star-Telegram* interview. As a result, UT Arlington began to make the campus accessible. "The significance of that is," Hayes said, "that was before the law said you had to do it. UTA did it for the right reasons, and that's because it was the right thing to do." After graduation, Hayes became UT Arlington's first director of the Office for Students with Disabilities. In 1976, concerned that so many disabled people died early deaths because of a sedentary lifestyle, Hayes started and coached the UT Arlington Freewheelers, a wheelchair basketball team. "[Sport] is one of the best therapeutic tools we have," Hayes said in a 1984 *Dallas Morning News* interview. "Most people are put in a chair and told, 'That's it.' Sports let us break down the barriers between wheelchair people and able-bodied people and compete against our peers." In 1988, the team joined the National Wheelchair Basketball Association intercollegiate division and changed its name from the Freewheelers to the Movin' Mavs. Under Hayes's coaching, the Movin' Mavs won seven national titles and sent 20 athletes to the Paralympics. Hayes himself was a top athlete in both wheelchair basketball and wheelchair road racing. Hayes earned bronze medals for the men's 100m and 200m in the 1984 Paralympic Games. In 1986, he rolled his chair from Austin to Arlington to raise awareness of the Arlington Handicapped Association. He is shown here training for the event. But perhaps Hayes's greatest achievement was the example he gave and the impact he had on students with disabilities. "You can sit in a dark room watching TV and eating Cheetos for the rest of your life, if that's what you want," Hayes was quoted as saying in a 2008 *Dallas Morning News* article. "But you don't have to." Hayes died in 2008.

CHAPTER SEVEN

Diversions and Delights

Arlington has always known how to have fun. In simpler times, that meant buggy rides on a Sunday afternoon, gathering around the mineral well to hear the news, listening to the phonograph, and perhaps taking a 5¢ ride on the interurban to nearby Lake Erie for boating and dancing at the pavilion. Reporting on an open house at the *Arlington Journal* in 1904, the paper said: "There wasn't a bit of trouble about the Modus Operandi of entertainment. There never is about an Arlington crowd. They have sense enough to entertain themselves anywhere."

During the Great Depression, Arlington did not lack for amusement. In fact, one could say that Arlington went big-time in the 1930s. Oil and cattle magnate William T. Waggoner loved thoroughbred horses and racing so much that he built a $3 million racetrack and named it Arlington Downs. Located at what would later become the northwest corner of the intersection of Texas 360 and Division Street, Arlington Downs was state-of-the-art and attracted national attention.

At the other end of Division Street was the Top O' Hill casino. Top O' Hill started out as a mild-mannered tea room where ladies played bridge and looked out over the landscape, but it grew to include organized gambling, a brothel, and a nightclub. Barbed-wire fences, guard dogs, and imposing towers flanking the driveway protected Top O' Hill from raids. Only under the cover of darkness and rain, and by crawling on their hands and knees under the barbed wire and up the slope to the main house, were Texas Rangers able to make a surprise raid on Top O' Hill in 1935. "Equipment taken," reported the *Dallas Morning News*, "included three roulette tables, four dice tables, two blackjack tables, one chuck-a-luck table, 15 decks of cards, several thousand poker chips and a hatful of dice."

Sports have always been a favorite pastime of Arlington, whether at the public school, college, or professional level. Photographs from the 1920s show both girls and boys playing basketball on school teams. Football came to Arlington in 1904 when Carlisle Military Academy formed a squad. Baseball was so ubiquitous in the region that, in 1911, the town of Cleburne prohibited residents playing on Sunday so as to preserve the sanctity of the day. "It can't be denied," opined the *Arlington Journal* in 1905, "that Sunday baseball playing has made itself so disreputable as to have forfeited the patronage and justly so of our better class of citizenship." The people, however, would not be denied, so Sunday playing went on unabated, except in Cleburne.

Six Flags Over Texas, which opened in 1961, ushered in a new era of entertainment. Inspired by Disneyland, Six Flags put a Texas twist on the theme park concept by devoting sections of the park to different eras in Texas history, from the Conquistador period all the way to the space age. The immediate success of the park gave Arlington a national profile and established the city as a tourist destination.

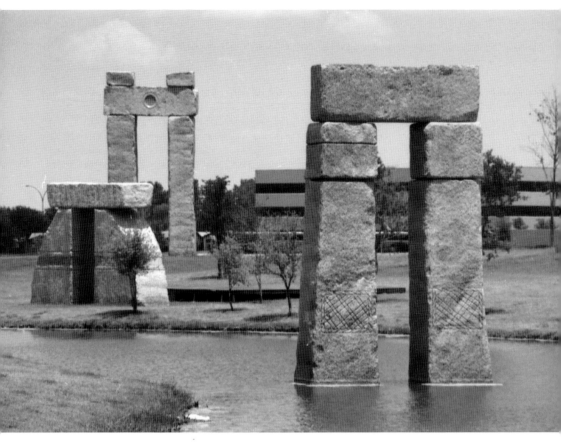

Caelum Moor

Caelum Moor, Arlington's own Stonehenge, was commissioned by Jane Mathes Kelton as the artistic centerpiece of a planned business park to be called the Highlands of Arlington. Kelton was the daughter of television manufacturer Curtis Mathes and chose the name Highlands and the style of the "environmental art" to honor her Scottish heritage. The 540-ton sculpture, made of pink Texas granite quarried in Marble Falls, Texas, was made by California sculptor Norm Hines and dedicated in 1986. It is shown here in 1988 at its original location on the north side of I-20, west of Matlock Road. The business park was never built, and in 1997, Caelum Moor was dedicated to the city of Arlington to be used in a park. The cost of moving the stones and the uncertainty of where to place them meant that Caelum Moor was placed into storage. The stones stayed out of sight until 2009, when they were erected in Richard Greene Linear Park. Kelton never saw their new home. She died in 2007.

Fred Browning and Lew Jenkins

In 1926, Browning became a part of Arlington's story when he purchased Beulah Marshall's Top O' Hill Terrace Tea Room with its panoramic view of the Fort Worth skyline on West Division Street. He had plans to serve more than the dainty teatime meals that were Marshall's specialty. Browning and his wife, Mary, transformed the tearoom into a luxurious destination with a tea garden and more. He moved the house aside, dug a two-level basement with secret escape tunnels, and then moved the house back. The casino he built beneath was a fortress with three trapdoors into smaller rooms that concealed gambling equipment. He constructed a secret room with two-way mirrors so that he could monitor players on the slot machines, crap and blackjack tables, and roulette wheels. High rollers and celebrities were entertained by popular bands of the era including Benny Goodman, Herman Waldman, and Tommy Dorsey, and dancers such as Ginger Rogers and the Texas Rockets. Forbidden alcoholic drinks brought to the casino by bootleggers enhanced the good times. Drinks and food were free, while gambling chips cost money. Among the long list of celebrities who came to Arlington and the Top O' Hill Terrace were Howard Hughes, Gene Autry, Lana Turner, and Hedy Lamarr. The doors also opened for the infamous, such as Bonnie Parker, Clyde Barrow, and Bugsy Siegel. Top O' Hill eventually had an Olympic-sized swimming pool, a horse barn, and a brothel. Browning also built a small gym and sparring ring for celebrated boxer Lew Jenkins. Pictured here are, from left to right, Fred Browning, Lew Jenkins, and Hymie Caplin celebrating Jenkins's new title of world lightweight champion that he won at Madison Square Garden on May 10, 1940. Decorative wrought iron gates with twin sandstone guard towers protected the enterprise's entrance. Guards signaled the casino when the police demanded entrance. The alarm system, secret rooms, and hidden tunnels were necessary because of repeated raids by law enforcement in an attempt to close it down. In the early 1950s, the raids and threat of publicity for unlucky gambling patrons signaled the end of what was arguably one of Arlington's most interesting attractions.

William Thomas Waggoner

Rancher and oilman William T. Waggoner made a major investment in Arlington when he opened the $3 million Arlington Downs racetrack in 1929. Known as one of the finest tracks in the country, Arlington Downs brought in celebrities such as Will Rogers, politicians like Vice Pres. John Nance Garner, and millionaires from across the country. After pari-mutuel betting laws were repealed in 1937, Arlington Downs became a venue for rodeos and auto racing. In the 1947 photograph at right, Waggoner's son, E. Paul Waggoner, leads a parade through downtown to celebrate the opening of the Third Annual Arlington Rodeo at Arlington Downs. William T. Waggoner died in 1934, and the track was razed in 1958.

Billy Joe Thomas

Pop, country, and gospel—Arlington resident B.J. Thomas has been singing and blending these genres for more than 40 years. His 1969 hit "Raindrops Keep Fallin' on My Head" was written for the movie *Butch Cassidy and the Sundance Kid.* Other hits include 1968's "Hooked on a Feeling" and 1975's "(Hey Won't You Play) Another Somebody Done Somebody Wrong Song." The five-time Grammy winner still tours around the world.

Pantera

In the early 1980s, Arlington brothers "Dimebag" Darrell Abbott and Vinnie Paul, left, formed the heavy metal band Pantera with fellow Bowie High School students Rex Brown, far right, and Terry Glaze. New Orleans–native Phil Anselmo, second from right, replaced Glaze in 1986. Pantera's success peaked with 1994's *Far Beyond Driven,* which debuted at no. 1 on the Billboard album sales chart. Pantera disbanded in 2003. (Courtesy Stuart Taylor.)

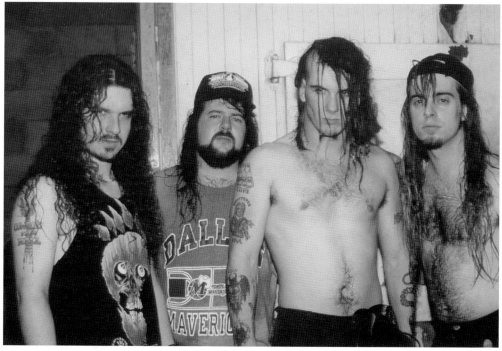

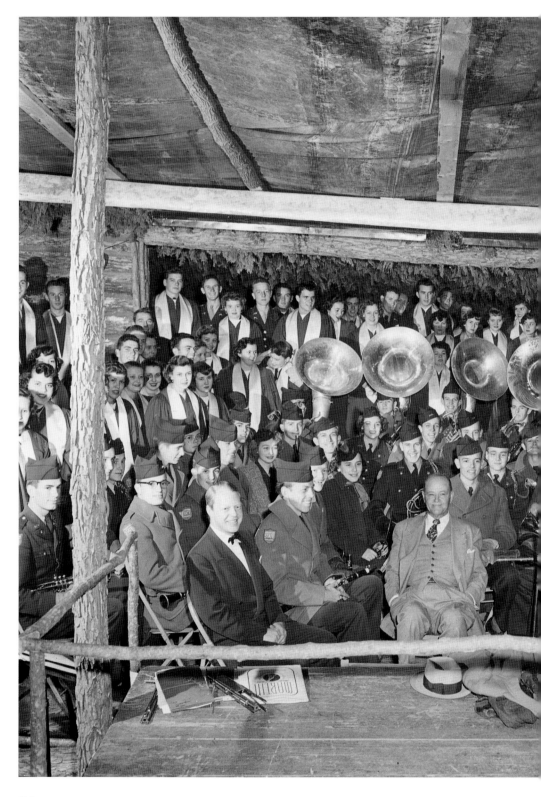

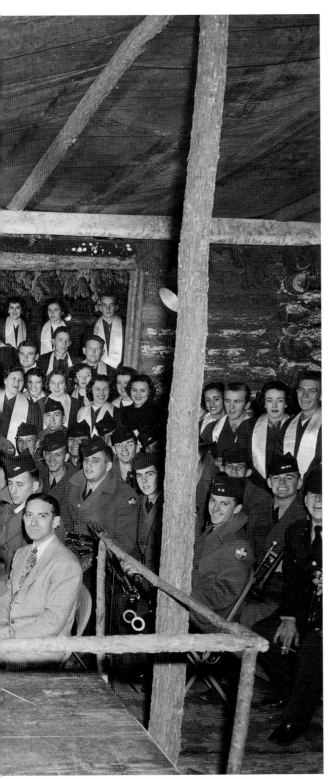

Dan Burkholder

If there was music in the air at Arlington State College, choirmaster and orchestra leader Dan Burkholder was probably nearby. When Burkholder came to North Texas Agricultural College in 1947, the NTAC choir had 12 students. By 1951, when this photograph was taken, ASC featured the One Hundred Singing Rebels choir. Burkholder (seated left foreground) is accompanied by Col. Earl D. Irons (center), head of the Fine Arts department, and band director James West. During his 29 years at the college, Burkholder directed the students for shows that included legends like Bob Hope, Dan Rowan and Dick Martin, and Steve Lawrence and Eydie Gorme. He also formed his own orchestra, the Danny Burke Band, as a way to help students earn money for school.

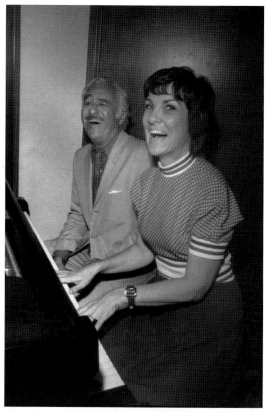

Persis Forster

Persis Forster has been nurturing young dancers at the Miss Persis Studio in Arlington since 1954. Shown at right with Barnett Shaw rehearsing for *Cabaret* in 1973, Forster has performed in numerous productions for Casa Mañana, Theater Arlington, UT Arlington, and others. She is also known for her choreography skills. She has helped produce *Gown Town*, a summer musical series in the 1980s, and various local high school productions. "I've touched a lot of lives and I've been very blessed to have a lot of talented people and blessed to have a sense of humor to be teaching this long," Forster said in a 2000 *Fort Worth Star-Telegram* interview. "When you see them develop the love of music, dance and fine arts, it's very satisfying and thrilling." The photograph below shows Forster's daughter, Persis Ann, with Miss Persis students in 1982.

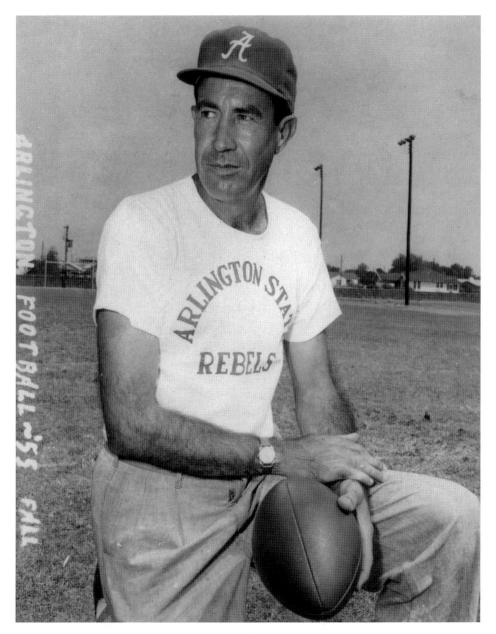

Claude "Chena" Gilstrap

Claude "Chena" Gilstrap came to Arlington State College in 1953 with a winning record at his previous football coaching jobs. In short order, he led the ASC Rebels to back-to-back Junior Rose Bowl victories in 1956 and 1957. By the time Gilstrap left coaching to focus on the job of athletic director, his Arlington record was 85-40-3, including an undefeated 1957 season.

Off the field, Gilstrap was a highly sought-after dinner speaker and master of ceremonies. "Smallest crowd I ever talked to, outside of my family, was at a church dinner," Gilstrap recalled in a 1969 *Dallas Morning News* interview. "I got there and found the tables set for 75 people. Nine showed up. It wasn't so bad, though. They served dessert six times." Gilstrap retired in 1978. The campus's athletic building was named for him in 1995.

Little Arlie

On November 2, 1950, Tom Vandergriff stood before an Arlington High School student assembly. He spoke a few words then suddenly said: "Here is the Arlington Colt!" With a swish, the heavy stage curtains were pulled back to reveal a white Shetland pony on the stage. "Pandemonium broke loose," said superintendent W. Ross Wimbish. The pony was a gift from Hooker and Tom Vandergriff to Arlington High School whose mascot was the Colts. Tom revealed that the idea for a live mascot had been Harry Moore's from Moore's Funeral Home.

The pony was referred to as "Mr. X" until the students selected a name for him through a student council vote. Students voted for one of 10 possible names: Victor, Vanco (for VANdergriff COlt), Vandy, Touchdown, Little Arlie, Lucky, Spirit, Willie, Champ, and Arco (for ARlington COlt). The results of the ballot were kept secret until halftime during the November 10 home game against Pleasant Grove. There, the pony was officially christened Little Arlie, and the Colts won the game 22-0. Arlie quickly became a school favorite and attended many important functions and games. Over the years, several ponies have played the role of Little Arlie. Arlie is shown in this 1965 photograph with handlers John Wehner (left) and Gary Cook.

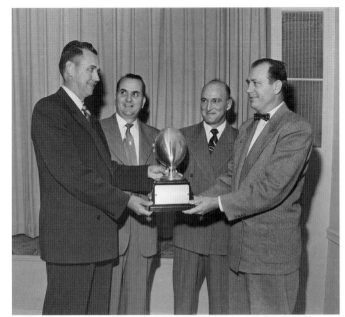

Mayfield "Bull" Workman
Coach Mayfield "Bull" Workman is often credited with guiding the Arlington High School Colts in a 7-0 victory over the Waco La Vega Pirates in 1951, when they won the state football championship. From left to right are Dr. Rhea Williams presenting the Conference AA football trophy to Coach Mayfield Workman, Principal James Martin, and Arlington superintendent Ross Wimbish.

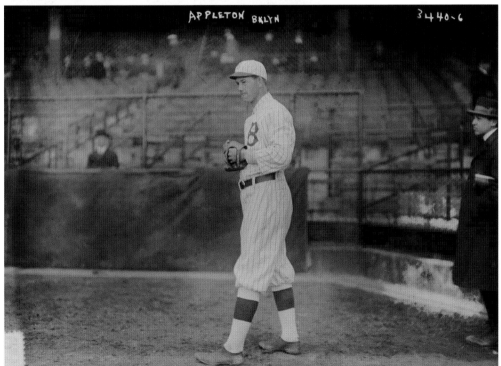

Edward "Whitey" Appleton
Born in 1892, Ed Appleton became the first major league baseball player from Arlington. Described as "tall" and "stout," Appleton pitched for the Brooklyn Dodgers from 1915 to 1916 and played in the 1916 World Series. Brooklyn lost the series to the Boston Red Sox four games to one. He interrupted his career to fight in World War I and then returned to play. Appleton died at age 39. (Courtesy Library of Congress.)

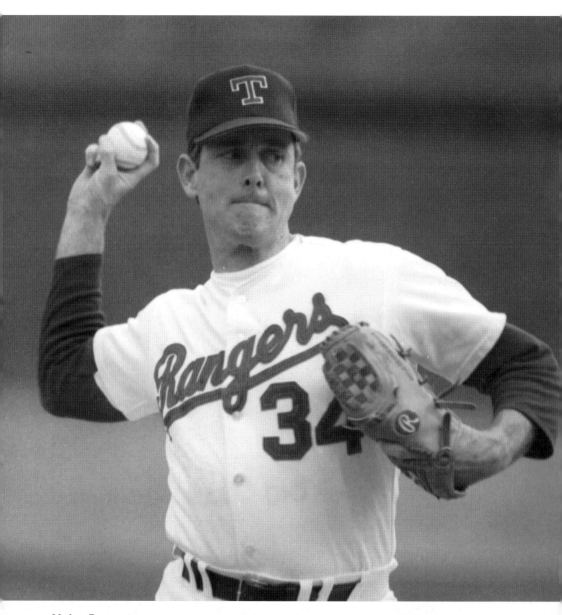

Nolan Ryan

"He's baseball's exorcist," said Detroit Tigers outfielder Dick Sharon in 1974. "He scares the devil out of you." The "he" is Nolan Ryan, former Texas Rangers pitcher and current Rangers team owner. Ryan joined the Texas Rangers in 1989 and propelled himself and the team to superstardom. He recorded strikeout number 5,000 in 1989, won career victory number 300 in 1990, and pitched his seventh no-hitter in 1991. "But I'm not primarily motivated by numbers," Ryan said in a 1989 *Houston Chronicle* interview. "Some people may find that hard to believe because there are so many numbers associated with my career. But it's true." After retiring in 1993, Ryan rejoined the Rangers as president in 2008. In 2010, he, along with partner Chuck Greenberg, bought the Rangers and watched the team advance to its first World Series.

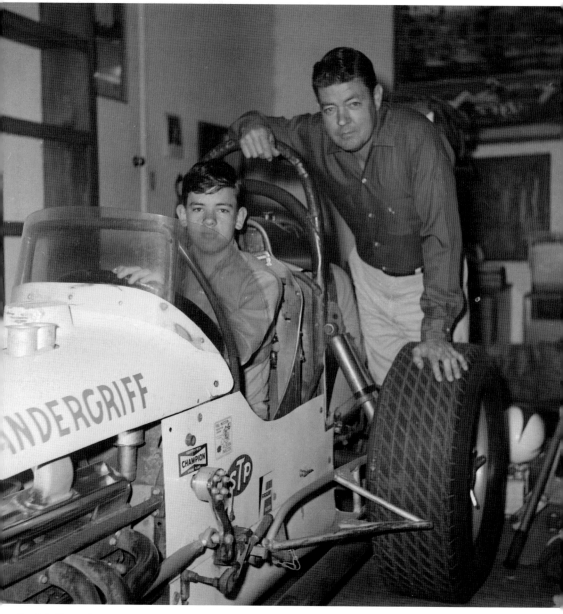

Jim McElreath

What do A.J. Foyt, Mario Andretti, and Al Unser Sr. have in common? They all lost to Arlington-born racecar driver Jim McElreath. McElreath, a lifelong resident, raced in the top echelons of American open-wheel motorsport. He started in 15 Indianapolis 500s between 1962 and 1980 and was named Rookie of the Year in 1962. He finished third in 1966, his highest finish at the Brickyard. McElreath's career spanned 50 years—an unheard-of length for today's drivers. In his very first race in 1945, he placed second. He quit racing in 1995 to take care of his wife, Shirley. He is shown here with his son James (15) in 1969. James followed his father's footsteps and became a driver but died in a 1977 sprint car accident.

Doug Russell

Born in Midland, Doug Russell came to the University of Texas at Arlington as a competitive swimmer in 1965. Doug was a standout athlete, earning AAU and NCAA championships. In 1968, Russell competed as part of the US Olympic team in Mexico City. Russell scored an upset victory over Mark Spitz and won the gold for the 100-meter butterfly. Later in the games, he won a second gold for the 4x100-meter medley relay.

Jeremy Wariner

In his first track competition as a Lamar High School sophomore, Jeremy Wariner set a school record. He only got better. Here, Wariner competes for Lamar in 2001. At this meet, he set a 400-meter regional meet record that stood for more than 10 years. He has numerous track medals and records, including two gold medals in the 2004 Olympics and a gold and silver in 2008. (Courtesy Wariner family.)

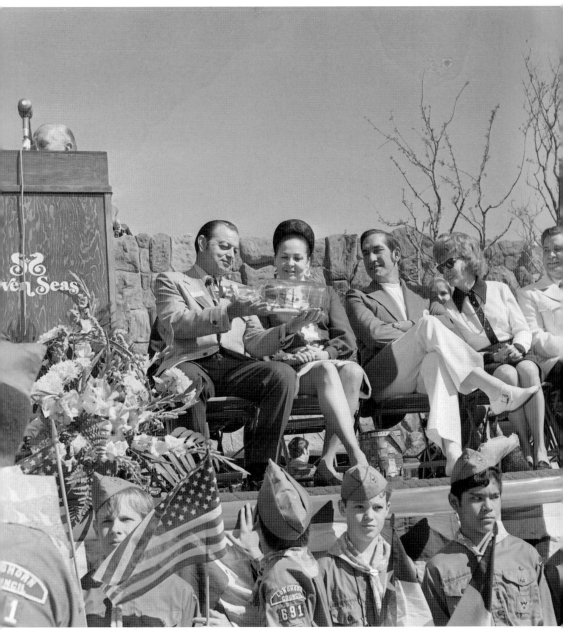

Seven Seas

Seven Seas, a $13.4 million sea life park, was built to expand Arlington's reputation as an entertainment center. The city built Seven Seas in a prime location—between Arlington Stadium and Six Flags—and opened it on March 18, 1972. True to the Seven Seas theme, the park was divided into seven areas: Arctic, Mediterranean, Indian, Sea of Cortez, Caribbean, Sea of Japan, and South Seas. Notable attractions included Newtka the killer whale, Pancho the sea elephant, and penguins on roller skates. In this photograph, Mayor Tom Vandergriff and his wife, Anna Waynette, admire a model of another Seven Seas attraction, the pirate ship *Bona Venture*, on opening day in 1972. Sadly, Seven Seas never caught on with the public, and it closed in 1975.

Teresa Pool
Teresa Pool was the first person through the gates at Six Flags Over Texas when it officially opened on August 5, 1961. She is shown at the turnstile with her parents and three of her brothers.

Charlie Patton
Charlie Patton retired from the Texas and Pacific railroad and started a second career at Six Flags Over Texas. He joined the park in 1961 and drove the narrow-gauge steam engines. Shown here in 1975, he retired from Six Flags in 1981 at age 94. At his retirement party, Six Flags announced that the Lamar would be renamed the Charles Jefferson Patton in his honor.

Six Flags Over Texas

On August 5, 1961, Arlington became—surprisingly—the heart of family entertainment in the southwestern United States with the opening of Six Flags Over Texas. "Arlington's growth and that of Six Flags are tied so one to the other, they're inseparable," said former mayor Tom Vandergriff in a 1986 *Dallas Morning News* interview. "It was one of the most important events in Arlington's history, adding a dimension that's just priceless. We wouldn't be nearly as large as we are without Six Flags." Six Flags was conceived as a way to fund the infrastructure for the Great Southwest Industrial District, a unique master-planned business park developed by Angus G. Wynne Jr. But the park soon became a sensation, attracting more than a half-million visitors from all 50 states in its abbreviated first season. The park benefitted from a perfect storm of events and people: an energetic and ambitious mayor in Vandergriff; a savvy, dedicated developer in Wynne; an ideal location between two major cities; and the newly opened Dallas-Fort Worth Turnpike (I-30) to facilitate travel. Together, these elements nurtured a park that became the nation's first successful regional theme park.

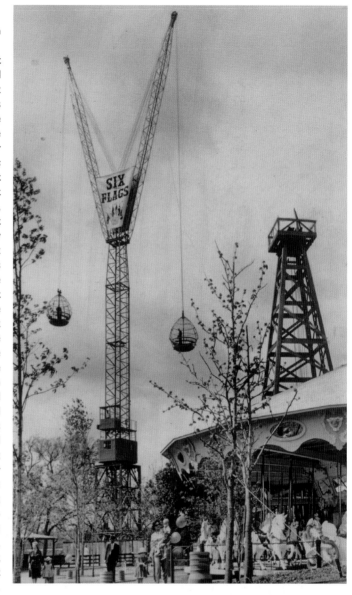

Six Flags used the theme of Texas history to develop the six sections of the park: Spain, France, Mexico, Texas, the Confederacy, and the USA, or Modern, section. Each section had rides and attractions that supported the theme. For example, the France section took dramatic license with the historic and ill-fated La Salle expedition. Employees in the Spain section dressed like Spanish explorers in pantaloons and helmets. Wynne bought an actual historic bank from the town of Tom Bean, Texas, and moved it to the Texas section of the park for authenticity. As the park grew and added more attractions, the historic areas became less identifiable. Boomtown opened in 1963 and Good Time Square in 1973. This photograph was taken in 1965. The Shock Wave and Judge Roy Scream roller coasters pushed Six Flags' boundaries outward. Quaint rides like goat carts, slides, and canoes that you had to paddle yourself gave way to roller coasters like Big Bend or contraptions like the Spinnaker. Today, the only ride still operating from 1961 is the Six Flags Railroad. Since its opening more than 50 years ago, Six Flags has remained one of the top tourist destinations in the state.

INDEX

AN IMPRINT OF ARCADIA PUBLISHING

Find more books like this at
www.legendarylocals.com

Discover more local and regional history books at
www.arcadiapublishing.com